One Hundred Master Drawings
from New England Private Collections

ONE HUNDRED MASTER DRAWINGS

from

NEW ENGLAND PRIVATE COLLECTIONS

Franklin W. Robinson

WADSWORTH ATHENEUM Hartford, Connecticut

HOPKINS CENTER ART GALLERIES Dartmouth College

MUSEUM OF FINE ARTS Boston, Massachusetts

Hanover, New Hampshire 1973

A Loan Exhibition

WADSWORTH ATHENEUM, HARTFORD
September 5 – October 14, 1973

HOPKINS CENTER, DARTMOUTH COLLEGE
October 26 – December 3, 1973

MUSEUM OF FINE ARTS, BOSTON
December 14, 1973 – January 25, 1974

Distributed by
The University Press of New England, Hanover, New Hampshire

This project
has been supported by a grant from the National Endowment
for the Arts in Washington, D.C., a Federal Agency

On the cover:
Detail, Jackson Pollock, no. 93

Table of Contents

Foreword

THE PRESENTATION of an exhibition of master drawings is always an occasion of special significance. Intensely personal and rewarding, original drawings have over the centuries found their way into the albums or onto the walls of a special breed of collector; and they speak to us intimately of the artist as of those who acquire them. While the holdings of the drawing cabinets of New England's museums are relatively well known and have been exhibited from time to time, the extraordinary wealth of master drawings in the hands of an unexpected number of private collectors in our six-state region have on the other hand never been surveyed in depth. When Franklin W. Robinson, Assistant Professor of Art at Dartmouth College, conceived this project and undertook to make that survey and select an exhibition of its highlights, he found it a difficult task indeed to restrict himself to the imposed limitations, so numerous and exceptional in quality were the drawings that he discovered in a surprising variety of private collections. The end result of that process testifies once again to the important and continuing role of New England as the home of distinguished collections.

The participating museums are especially grateful to the many collectors whose willingness to make available for an extended period so many important drawings has made this exhibition possible. To Franklin Robinson, who has worked with vast energy on this project for nearly two years visiting dozens of collections and examining hundreds of fine drawings, and whose keen eye and able scholarship produced the final selection and the catalogue, we extend our deepest appreciation. There were many others who in ways too numerous to describe contributed in valuable ways to the project. To these—scholars here and abroad, members of the

staffs of our respective museums, assisting technical experts, and helpful friends—
we offer our most sincere thanks. Finally, for the generous assistance provided by a
grant from the National Endowment for the Arts which helped make the exhibition
and catalogue a reality, we are especially grateful.

TRUMAN H. BRACKETT, Jr.
Director, Hopkins Center Art Galleries,
Dartmouth College

PETER A. MARLOW
Chief Curator, Wadsworth Atheneum, Hartford

ELEANOR A. SAYRE
Curator of Prints and Drawings,
Museum of Fine Arts, Boston

Lenders to the Exhibition

Mr. and Mrs. George S. Abrams,
9–11, 13, 15, 16, 22, 27

Mr. and Mrs. Winslow Ames,
14, 19, 23, 29, 31, 32, 36, 49

Mr. and Mrs. Paul Bernat, 20, 38

Dr. and Mrs. Malcolm W. Bick, 7

Mrs. Jean Brown, 93

Mr. Paul W. Cooley, 83

Professor and Mrs. S. Lane Faison, Jr., 94

Professor Sydney J. Freedberg, 6

Mr. H. Sage Goodwin, 86

Mr. and Mrs. John Davis Hatch, 12

John Davis Hatch Collection of Drawings
by American Artists, 47, 48, 61

Professor and Mrs. Julius S. Held, 2, 5, 17,
41, 42, 46, 65, 70, 82, 84

Freddy and Regina T. Homburger
Collection, housed at the Maine State
Museum, Augusta, Maine, 57

Miss Agnes Mongan, 28

Mr. and Mrs. Stephen D. Paine,
75, 90, 91, 96, 97, 99, 100

Mr. Edmund P. Pillsbury, 78

Belle K. Ribicoff (Mrs. Irving S. Ribicoff),
88, 92

Mr. and Mrs. Eric H. L. Sexton, 24, 34

Dr. and Mrs. Maurice Shulman, on loan to
the University Gallery, University of
New Hampshire, 37

Professor and Mrs. Seymour Slive, 25

Mr. James Thrall Soby, 85

Mr. and Mrs. Roger P. Sonnabend, 98

Wasserman Family Collection, 60, 95

Professor and Mrs. Melvin J. Zabarsky, 35

Anonymous lender, 1, 18, 21, 33, 40, 66, 72

Anonymous lender, 3, 52, 69

Anonymous lender, 4, 45

Anonymous lender, 30, 89

Anonymous lender, 55, 63, 64, 71, 73

Anonymous lender, 56, 87

Anonymous lender, 58, 62

Anonymous lender, 74, 76

Anonymous lender, through the Fogg Art
Museum, 79, 81

The other drawings in the exhibition have
been lent singly by twelve anonymous lenders.

Author's Acknowledgments

T HIS PROJECT began in the Spring of 1971, and from its inception to its completion—from the first idea for the exhibition to discussions with many museum people, over sixty collectors, the National Endowments for the Arts, photographers, scholars, and printers, among others—I have been helped and encouraged by everyone I met. This has, perhaps, been the best part of the experience, and I am particularly grateful to the large number of collectors I visited, forty-five of whom have so generously given up their drawings for almost six months to make this exhibition possible.

I must also mention Marjorie B. Cohn and Herbert P. Vose, who accompanied me on so many trips throughout New England; Mrs. Cohn opened the framed drawings, took their technical data, and closed them again, and Mr. Vose photographed them. The work they did on specific drawings is listed elsewhere in this catalogue; but I would like to add my thanks for their patience, help, and advice, far beyond what anyone could have expected.

Many scholars have been generous with their knowledge in one way or another. J. G. van Gelder and Ingrid Jost wrote the entry for the Cuyp (26). John Hallmark Neff contributed information on one Matisse drawing (73), and wrote the entire entry for the other (72). Eleanor A. Sayre prepared the entry for the Goya (43), and Robert P. Welsh wrote the entry on the Mondrian (74). To all of them I am especially grateful. Margaret Robinson did much of the research on the four Degas drawings (57–60).

Other scholars who have been of great help include George S. Abrams, Clifford S. Ackley, Winslow Ames, J. Bolten, S. Lane Faison, Jr., Alan Fink, Sydney J.

9

Freedberg, Eleanor M. Garvey, H. Gerson, Felton Gibbons, Julius S. Held, Michael Mahoney, Thomas McCormick, Stephen E. Ostrow, Jane E. Radcliffe, Theodore E. Stebbins, Jr., J. Q. van Regteren Altena, Hope S. Rider, Richard Wallace, Richard West, William T. Wiley, and Melvin J. Zabarsky; a special debt is owed George Knox and E. Haverkamp-Begemann. Margaret Sweetland compiled birth and death dates and places at the head of each entry. I am particularly grateful to Molly O'Connor and the staff of the Art Library, Dartmouth College, for their patience and help. The Stinehour Press has done its usual superb job of producing a beautiful catalogue.

David Horne, editor of the University Press of New England, Hanover, New Hampshire, has kindly undertaken to distribute this catalogue after the exhibition has ended.

I am deeply grateful to the three museums for sponsoring this exhibition; their staffs have been helpful at every stage. The assistance of the Office of Registrar at the Museum of Fine Arts, Boston, has been a great help with insurance arrangements. I am particularly indebted to Peter O. Marlow, Chief Curator at the Wadsworth Atheneum, who devoted several days to introducing me to collectors I never would have met otherwise, as well as to other tasks. The staff of the Hopkins Center Art Galleries has performed the onerous task of typing most of the several hundred letters I have had to write and all of this long catalogue. Finally, I am, once again, in the debt of Truman Brackett, Director of the Galleries, my friend and collaborator on so many of these projects over the last four years.

F. W. R.

Introduction

O ver the last few years, there have been, in the United States, several exhibitions of drawings drawn from collections located in one city or state or collection of states, for example, the series of exhibitions of Italian drawings from New York City collections at the Metropolitan Museum and the Morgan Library, *Italian Drawings Selected from Mid-Western Collections*, at the St. Louis Art Museum, *Master Drawings from California Collections*, at the University Art Museum, Berkeley, and *Drawings and Watercolors from Minnesota Private Collections*, at the Minneapolis Institute of Arts. There have, occasionally, been such exhibitions for the New England area, most notably, at the Museum of Fine Arts, Boston, in 1939; certainly, there is a wealth of material in private hands in these six states and a long tradition of collecting drawings.

Indeed, the earliest drawing collector of any seriousness in America seems to have been James Bowdoin III, a Minister to the court of Spain and the court of France, who left his collection to Bowdoin College in 1811; Henry Johnson (*Catalogue of the Bowdoin College Art Collections*, I, Brunswick, 1885) lists 142 drawings from Bowdoin, most of them sixteenth- or seventeenth-century Italian, Netherlandish, or French, including a famous landscape by Pieter Brueghel. W. G. Constable (*Art Collecting in the United States of America*, London, 1964, pp. 155–168) has dealt at length with his successors in the nineteenth century, such as John Witt Randall of Boston, and, more recently, the influence of Harvard University and Charles Eliot Norton and, most particularly, Paul J. Sachs. It has been through the Fogg Art Museum, and especially its program of graduate study and such donors in the drawing field as Sachs, Charles Loeser, and Grenville Winthrop, that much of

the present interest in drawing has been inspired in New England, and particularly the Boston area, the richest in collections of graphic art.

In fact, the vitality of a collecting tradition here is clearly documented in an exhibition such as this one; forty-five collectors are represented, and this writer visited more than a dozen others and has, too late, learned of still others. The variety in these collections is extraordinary; in one case, the drawing lent to this exhibition is the only one in the lender's possession, in another case, the lender has over two thousand drawings. Collections of drawings that number close to one hundred or in the hundreds are not uncommon. Also, although a large proportion of the collectors live in the Boston area, there are concentrations in Providence and Hartford, and all six states are liberally represented in the exhibition. The range of tastes and preferences is wide, but certain common predilections can be found: the Tiepolos have proved to be strong favorites, not surprisingly, considering the brilliance, charm, and prolific output of this family, and Degas is a close second. Nineteenth-century draughtsmen, and to some degree, those of our own century, have been the major collecting focus; there are, also, many excellent collections of drawings of artists based in New England. Drawings executed before 1600 are rare and difficult to acquire today, but their extreme scarcity was still a surprise.

An exhibition such as this, comprised of only one hundred drawings, most of which have never before been published or exhibited, cannot provide a true history of Western draughtsmanship, but it can illuminate certain periods. For example, it is unexpected to find so many of the major streams of contemporary art expressed in drawings, from artists associated with Pop Art (Oldenburg, cat. no. 95, and Johns, 96), to environmentalists (Christo, 97), to concept art (Arakawa, 98), to funk (Wiley, 99) and sharp-focus realism (Close, 100). Similarly, a good range of Abstract Expressionists is represented, including De Kooning, Gorky, Smith, Pollock, and Motherwell (90–94). Enough drawings by Degas and Picasso are present to give some idea of at least part of their development (57–60, 79–81). One can even trace the convulsive changes of style over a whole continent, for example, in the second half of the eighteenth century: the rococo brilliance of Giovanni Battista Tiepolo (30) and the early Domenico Tiepolo (35), of Fragonard (40) and Boucher (32), of Troger in Austria (31), and even Gainsborough in England (34), is gradually replaced not only by the neo-classicism of Mengs (39) but by a heightened fantasy and emotional intensity apparent in artists living in England, such as Romney (41), West (42), and Blake (45), and also, dramatically, in Goya (43). Even the

genre subjects of Rowlandson (44) and the late Domenico Tiepolo (38) respond to these new currents. Another interesting aspect of the collections formed in New England is an emphasis on nineteenth-century American drawings, six or seven of which are included here; they range in subject from a religious scene inspired by European models (West, 42), to a study for a painting depicting the landing of Columbus (Vanderlyn, 47), to a native American landscape (Heade, 53), to, finally, two views of blacks (54, 65).

The range of subjects, finally, can also be illuminating. Within the seemingly narrow realm of seventeenth-century Dutch and Flemish landscape drawings, the delicacy and precision of the Cuyp (26) contrasts beautifully with the Rembrandt-esque spontaneity and chiaroscuro of the Roghman (16) and the Rubensian atmospheric effects of the Van Uden (15), while the Rutgers (27), dated 1690, looks forward to the more careful, quiet topographical views typical of the eighteenth-century Netherlands. The classical restraint of La Hire's and Lesueur's religious compositions (17, 23) is balanced by the more intimate, personal dramas of Guercino (12) and Rembrandt (18); all four drawings are done in the two decades between the middle 1620's and the middle 1640's. Interestingly, four of the French drawings, by Fragonard (40), Delacroix (49), Daumier (51), and Doré (56), were not only intended as illustrations for literary works in some form or other but, indeed, are clear attempts to capture their spirit. Finally, these artists return again and again to the human face, and it is appropriate that both the first drawing in this exhibition, from the fifteenth century, and the last, by an artist in his early thirties, should be intense, and troubled, portraits.

The Catalogue

The entries are arranged chronologically, by the artist's date of birth. The dimensions are given in inches, height preceding width. Marjorie B. Cohn has written the descriptions of medium, dimensions, support and watermarks, inscriptions and collector's stamps for the following entries: cat. nos. 1, 4, 6, 8, 18, 20, 21, 24–26, 28, 30, 33–35, 37–40, 44, 45, 50, 56, 58–60, 62, 66, 68, 72, 75, 77–81, 85, 87, 89–91, 95–100. "Lugt" refers to Frits Lugt, *Les Marques de Collections* . . . , with *Supplément*, The Hague, 1956. Illustrations of the versos of the following drawings will be found at the end of the catalogue: cat. nos. 9, 26, 55, 62 (detail), 78, 85, 91.

LUCA SIGNORELLI *Cortona 1441 (?) – 1523 Cortona*

1 HEAD OF A YOUNG MAN. Verso: studies of male figures.

Black chalk on tan antique laid paper. The broad outlines of the drawing have been traced over with a stylus. The stylus lines are heavily pigmented, suggesting that the original depth of tone of the drawing has been preserved only in these areas depressed below the sheet's surface where the pigment has been forced into the sheet. A less satisfactory explanation for these dark stylus lines would presuppose the existence of an earlier study whose verso had been blackened and whose outlines were then transferred to this sheet by tracing with a stylus. This possibility seems inconsistent with the drawing's general appearance as a sketch and with the discovery of studies of male figures on the verso, which further point to this drawing being a study sheet rather than a second generation, developed conception. Somewhat rubbed and stained. 8¾ × 6⅞ (irregular).

Lower right, a collector's stamp in violet, *D* and superimposed *U* within an oval (unidentified, not in Lugt). On the back of the frame, a label, and, in pen and ink, *A.G.B. Russell.*

PROVENANCE: De Clementi; A. G. B. Russell; Sotheby's, London, May 22, 1928, no. 89.

LITERATURE: Bernard Berenson, *The Drawings of the Florentine Painters*, amplified edition, Chicago, 1938, II, p. 334, no. 2509F, and III, fig. 94; Hans Tietze, *European Master Drawings in the United States*, New York, 1947, p. 44, no. 22.

Anonymous lender. John N. Brown

This precious drawing, the only one from the fifteenth century in this exhibition, has been incised for transfer, probably to a fresco; as Berenson has pointed out (II, p. 334), it is probably for one of the figures in Signorelli's greatest work, his frescoes in the S. Brizio chapel in the Cathedral at Orvieto, and particularly for the *Resurrection*, ca. 1499–1505. The drawing is close to other drawings of youths looking upward, such as the John the Baptist, 1484, in Stockholm (Berenson 2509I, fig. 95). The drawing is clearly a fragment; to the right are a few lines that suggest tendrils of hair, while on the left are several other lines that remain inexplicable. As Berenson remarks, the pose and facial type indicate the influence of Perugino; but there is in Signorelli a greater monumentality, more of a feeling for the bone and muscle beneath the smooth, radiant skin, and a more intense spiritual urgency, especially in these large frescoes with their visions of resurrection and damnation.

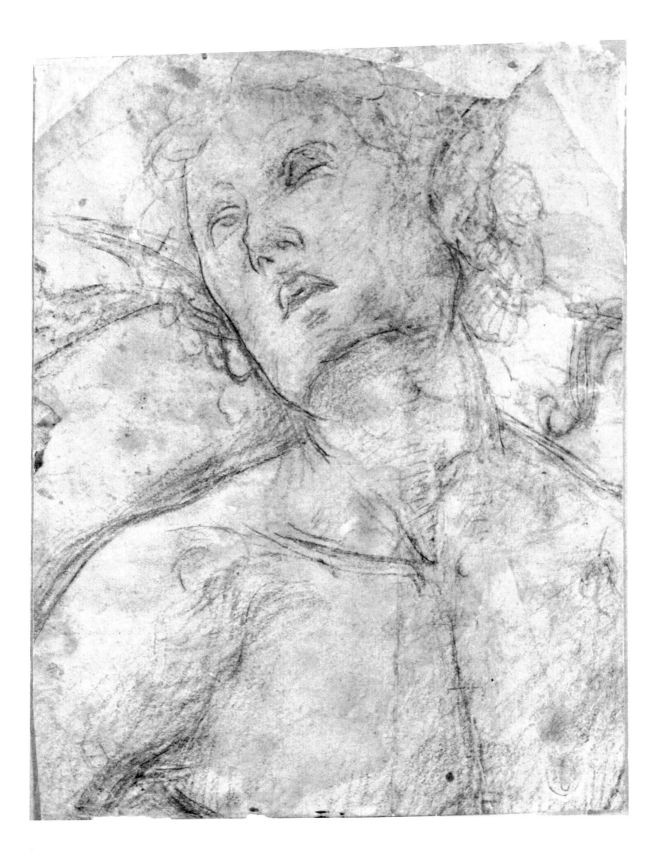

JEAN COUSIN THE YOUNGER *Sens ca. 1522 – 1594 Paris*

2 THE VIRGIN AND CHILD WITH ST. JOHN AND ST. LUKE

Pen and black ink, brown wash, and red chalk; border in pen and brown ink by a later hand. Watermark: small armorial shield, surmounted by four circles in the center, and a circle on either side, with a circular design (chalice and pomegranate?) within the shield, the whole about 2 inches high. Some of the black pen lines are blurred, as if they had been damp once. Five or six small holes at the bottom have been repaired, with the pen lines filled in by a later hand. 14¼ × 12⅜.

Mark of the Laporte collection (Lugt 1170); verso, marks of the Sachs collection (Lugt 2091) and the Held collection (H, J, and S in monogram, in black ink).

PROVENANCE: G. Laporte; Paul J. Sachs.

LITERATURE: reproduced, *Connoisseur*, Sept. 1966, p. 29; *Selections from the Drawing Collection of Mr. and Mrs. Julius S. Held*, Binghamton, 1970, no. 59.

Professor and Mrs. Julius S. Held.

This charming drawing, with the Virgin and Child surrounded not only by St. John and St. Luke but also by over thirty putti bringing gifts to the Child, or singing or playing the violin, illustrates the international nature of French mannerism in the middle of the sixteenth century. It was once attributed to Niklaus Manuel Deutsch (when it was in the Sachs collection), and the tree does have the marvellous twisted vigor and complexity of Manuel's landscapes, and, indeed, of many of the landscape drawings and etchings from the Danube school. It is, instead, closer to such French artists as Jean Cousin the Younger and Etienne Delaune. At the same time, these artists show a clear dependence, at least in part, on such Italian artists who went to France as Rosso Fiorentino, Luca Penni, and Francesco Primaticcio. Particularly close to the present sheet are two drawings in the Louvre, Cousin's *Children Playing Among the Ruins* and Delaune's *Allegory of Religion*, as well as another, by Cousin, a *Crucifixion* in the Hessisches Landesmuseum, Darmstadt. Much the same format of the Virgin and Child seated in front of a tree filled with cherubs appears in a drawing from the School of Fontainebleau, in the Albertina (Inv. 2001, B. 38, Walter Koschatzky et al., *Italian Drawings in the Albertina*, Greenwich, Conn., 1971, no. 58).

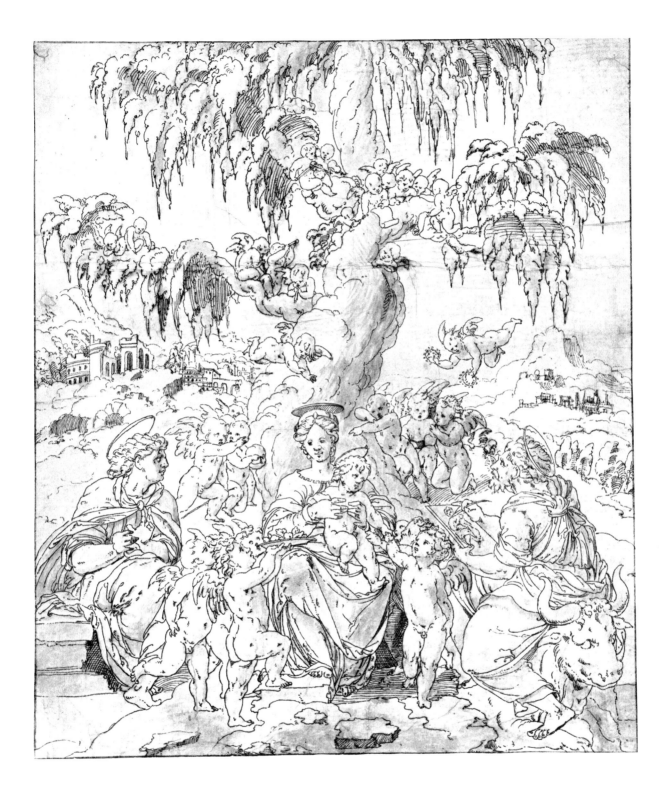

3 GRIMACING MAN

Quill pen and brown ink, touches of black chalk, on antique laid paper; laid down. $10\frac{15}{16} \times 7\frac{11}{16}$.
Mark of the Cosway collection (Lugt 629).

PROVENANCE: Richard Cosway; H. Shickman, 1964.

Anonymous lender.

This powerful drawing is by one of the more important followers of Michelangelo in the middle of the sixteenth century; indeed, this grimacing figure with bloated muscles may well have been inspired by one of the most eloquent of the damned in Michelangelo's *Last Judgment* in the Sistine Chapel, who crosses one arm over the other and places his left hand over the left half of his face.

Franco was born in Venice and worked in Rome and Florence before returning there; many of his paintings, such as *Christ Descending Into Limbo*, Galleria Colonna, Rome, are packed with similar figures, gesturing violently or in twisted poses. The artist came late to painting (W. R. Rearick, "Battista Franco and the Grimaldi Chapel," *Saggi e Memorie*, 2, p. 108), and his earliest works are drawings, usually copies after Michelangelo, Raphael, or other artists, or after antique reliefs. The present work has the long, wiry line and giantesque proportions of many of his drawings, for example, in the Albertina and the Ashmolean Museum (Stix and Fröhlich-Bum, I, nos. 133–147, Parker, II, no. 233).

MASTER M. S. German School, active 1557

4 HUNTER IN A LANDSCAPE

Black ink and quill pen over traces of black chalk on cream antique laid paper. 5⅞ × 8¼ (irregular).
Upper edge at center, in pen and black ink, (?) *1557 . Jar den 30 November –/ · MS·*

Anonymous lender. ∅. H. fer

In spite of the initials *MS* at the top of the sheet, the artist of this charming drawing remains unknown. It is not the Monogrammist MS who was influenced by Cranach and Jörg Preu and has left six dated paintings of 1506. Nagler (IV, no. 2163) lists an MS who was a still anonymous cutter of wood blocks in Nuremberg from 1545 to 1580. Indeed, the present work has the feeling of a printmaker's drawing, with each element of the scene carefully outlined and clear, regular crosshatching for the shadows, and the subject is one we expect to find among the "little masters" of Nuremberg—the hunter, with his camouflaged spurs, and falcon's hood in his right hand, creeping up, with his dog, on the downed prey on the left. Most particularly, the style of the draughtsmanship itself is close to that of Erhard Schön, who worked in Nuremberg and died there in 1542 (Nagler notes a Martin Schön in Nuremberg ca. 1550). Erhard Schön's drawings, such as those of the planets in the Wallraf-Richartz Museum, Cologne, and the University Library, Erlangen, have the small, tight figures and "engraved" quality to the line that might have been the inspiration for this work. Virgil Solis and Jost Amman are two other Nuremberg artists whose drawings are close in style to this hunter (Fritz Zink, *Die Handzeichnungen bis zur Mitte des 16. Jahrhunderts*, I, Nuremberg, 1968, p. 145).

5 THE JUDGMENT OF SOLOMON

Pen and black ink, black chalk, touches of graphite (?), pink and brown washes, heightened with white, with a border in pen and black ink, on pink antique laid paper; laid down. Traces of a vertical center fold. 8½ × 12⅝.

PROVENANCE: Duchy of Liechtenstein; W. Feilchenfeldt, Zurich.

LITERATURE: *Mannerist Drawings, Prints, and Paintings*, Davison Art Center, Wesleyan University, 1951, no. 71; F. Winkler, "The Anonymous Liechtenstein Master," *Master Drawings*, 1, 2, 1963, p. 34, pl. 31; *Selections from the Drawing Collection of Mr. and Mrs. Julius S. Held*, Binghamton, 1970, no. 88.

Professor and Mrs. Julius S. Held.

This artist, named for a series of drawings once in the Liechtenstein collection, has remained unidentified. It is clear, however, that he is a northern mannerist who worked in the middle of the sixteenth century. Friedrich Winkler (*Master Drawings*, 1, 2, 1963, pp. 34–38) suggested a Netherlandish origin for the master, while pointing out some connections with Germanic themes and prints; the collector favors South Germany, Austria, or Switzerland, or, if it is the southern Netherlands, an artist close to Lancelot Blondeel. Indeed, in spite of the Netherlandish overtones in many of the drawings, the expressive energy of these twisted poses, complex, imaginary buildings, and rampant decoration seems closer to Germanic models, such as, earlier, Hans Holbein the Younger or the Master of Muhldorf or, later, Tobias Stimmer or Daniel Lindtmeyer.

The present sheet is typical of the master's drawings, with its interweaving and fragmenting of architectural detail, such as the open railing in the foreground and the views through colonnades to the sides and above, the distortions of perspective and proportion, making the figures in the foreground strikingly larger than King Solomon, the frozen, agonized poses, and even the surprising color of the pink prepared paper.

LUCA CAMBIASO *Moneglia 1527 – 1585 Madrid*

6 CUPID AND PAN STRUGGLING BEFORE VENUS AND THE THREE GRACES

Brown ink with reed pen, brown wash, white highlights in oil (?) on cream antique laid paper; laid down on an old mount. The entire surface has been heavily varnished; the varnish has darkened and yellowed. 11³⁄₁₆ × 11¹⁵⁄₁₆.

PROVENANCE: General Morrison?

Professor Sydney J. Freedberg.

Luca Cambiaso, to some degree outside the mainstream of contemporary art, was a provincial painter of remarkable power and originality. Born near Genoa, he worked there for most of his life, until, in 1583, he went to Spain to work at the court and paint a series of frescoes in the Escorial. His paintings, which influenced a number of Genoese artists and perhaps even the French Caravaggist Georges de la Tour, are characterized by massive, quiet and slow-moving forms, often with dramatic effects of artificial light.

His drawings, like this one, often show the influence of Michelangelo, as does the drawing of Battista Franco in this exhibition; his most famous works, in pen and ink and wash, show human figures reduced to their simplest, geometrically regular volumes, strangely similar to the automata and machine people of such later artists as Giovanni Battista Bracelli. The present drawing is related to a lost fresco executed between 1563 and 1565 in the Palazzo della Meridiana (formerly of the Duke Grimaldi), in Genoa (Bertina Suida Manning and William Suida, *Luca Cambiaso, la vita e le opere*, Milan, 1958, p. 92, and p. 192, fig. 170). The extraordinary number of drawings in Cambiaso's style, many of them copies, makes his work one of the most difficult challenges in drawing con-

noisseurship. For example, another version of the present drawing, almost precisely similar and of similar dimensions, is in the Art Museum, Princeton University, with an inscription on its verso, "Genl Morrison has a copy of this drawing executed in oil upon paper attributed to L. Cangiasi" (Robert L. Manning, *Drawings of Luca Cambiaso*, Finch College Museum of Art, New York, 1967, no. 12). Although his late drawings seem to be characterized by a greater freedom and looseness (Manning, 1967, no. 71), it is difficult to distinguish between two versions of the same subject in the Genoese period. Both drawings are of high quality, and both seem to be original. The features of the faces are more clearly, less clumsily, defined in the present drawing, and the faces show stress and anger, instead of being blandly uncommunicative. Also, the volumes of the body are heavier and more tangible, and the architecture in the left background is more surely defined. Even such details as the wings and the two trees show greater care and control in their delineation. Nevertheless, Cambiaso himself made close copies of his own work; as Felton Gibbons (letter, April 10, 1973) has pointed out, the white heightening in the present drawing is unusual in Cambiaso's work.

BARTOLOMEO PASSAROTTI *Bologna 1529 – 1592 Bologna*

7 TWO-HEADED FIGURE

Quill pen and brown ink, on antique laid paper; laid down. Various paper losses have been retouched in pen and brown ink on the mount. The drawing has been incised throughout. Watermark of the mount (?): suspended powder horns, within a shield, about six inches long. $16\frac{7}{16} \times 10\frac{15}{16}$ (irregular).
Inscribed in pen and brown ink, upper right, *129*, and lower right, a star; in graphite, in a later (eighteenth century?) hand, in graphite, *Passerotti*.
PROVENANCE: Alister Mathews, 1971.

Dr. and Mrs. Malcolm Bick.

Bartolomeo Passarotti is another of the artists in this exhibition who, like Battista Franco and Luca Cambiaso, were deeply influenced by Michelangelo's draughtsmanship; Passarotti, who worked mainly in Bologna, saw Michelangelo's work firsthand during a sojourn in Rome. His large sheets, often of male nudes or monumental heads, with summary strokes and an open "engraved" cross-hatching, are extremely close to the drawings of the Florentine Baccio Bandinelli.

This handsome drawing, in spite of a certain hesitation in the right shoulder, is typi-cal of the master's work; a superlative example of Passarotti's powerful representations of single heads was in the Phillipps Fenwick Collection (A. E. Popham, *Catalogue of Drawings . . . in the possession of . . . T. Fitzroy Phillipps Fenwick*, n.p., 1935, p. 79, and opp. p. 80), and he frequently drew unusual subjects, such as the strange, but charming beast recorded here (see the painting of a butcher's shop, Galleria Nazionale, Rome, and the drawing of a grotesque man's face, Staatliche Graphische Sammlung, Munich). His son Tiburzio apparently was a close follower.

8 HUNTING SCENE

Brown ink with quill pen and brown wash over graphite with touches of white gouache on white antique laid paper; incised, and laid down on an old mount. 5¾ × 8⅜.
Signed in pen and brown ink, bottom center, *hans Bol | 1584*; verso of the mount, inscribed, *Hans-Bol · 1584 ·*

Anonymous lender. *F. Dehnatel*

Hans Bol was one of a number of artists—Frans Hals was another—who made their way from Flanders, occupied by the Spanish, to the northern Netherlands, in the late sixteenth or early seventeenth century, during the Dutch war of independence. The extraordinary number of drawings of his that have survived, and the many prints made after his designs, as well as his peripatetic nature, have made him an interesting figure to study, since the development of Dutch landscape, from the 1560's to the 1590's, can be traced in his work (see *Things of this World*, Sterling and Francine Clark Art Institute, Williamstown, 1972–1973, no. 7). Most particularly, Bol begins, about 1590, to grow away from his mannerist beginnings and presage the new conception of landscape, to achieve popularity in the following century.

The present drawing is just before this final phase; it and a companion piece in the same collection, also incised and signed and dated 1584, served as preparatory studies for a series of twenty-four engravings by the Antwerp printmaker Adriaen Collaert (two of these prints are reproduced in F. W. H. Hollstein, *Dutch and Flemish Etchings*, . . . , IV, p. 205, and three others in H. G. Franz, "Hans Bol als Landschaftszeichner," *Jahrbuch des Kunsthistorischen Institutes der Universität Graz*, I, 1965, figs. 172–174). There seems to be no unifying theme to the series; for example, the present drawing is a hunting scene, while its companion piece shows Jacob's ladder. The remarkable margins may be evidence of the influence of Georg Hoefnagel's miniatures in the Germanic lands and the Netherlands.

In 1584, Bol left Antwerp, where he had lived for the past dozen years, and went to the Netherlands and, ultimately, Amsterdam. The prints for which this drawing is one of the designs were printed in Antwerp, so they may have been executed, or at least commissioned, before he left.

ABRAHAM BLOEMAERT *Dordrecht 1564 – 1651 Utrecht*

9 A COURTYARD. Verso: a view of another courtyard.

Quill pen and dark brown ink, brown wash, grey wash, touches of green wash, heightened with white, and black chalk, on reddish antique laid paper. On both sides, a border in pen and dark brown ink. Small tear in lower right corner. 6⅜ × 8⁷⁄₁₆.

Inscribed by a later (eighteenth century ?) hand, in pen and dark brown ink, *ab. Bloemaert*.

PROVENANCE: A French collection; B. Houthakker, 1971.

Mr. and Mrs. George S. Abrams.

Abraham Bloemaert, with Hendrick Goltzius in Haarlem, was one of the most influential Dutch mannerists and was the teacher of many of the most important mannerist and Caravaggist painters of the Utrecht school, including several of his sons. Although Bloemaert's numerous drawings are difficult to date, the present sheet, an example of the master at his best, may be from the second, or even third decade of the seventeenth century, when Bloemaert's swirling mannerist calligraphy began to take on a more rectilinear feeling and a new openness in the definition of forms (see *Things of this World*, Sterling and Francine Clark Art Institute, Williamstown, 1972–1973, no. 6).

J. Bolten has pointed out (letter, February 14, 1973) that not only does Van Mander mention this kind of drawing in his biography of Bloemaert in his *Schilder-Boeck* but other examples can be found, as in Munich, no. 1078, also recto and verso. He goes on to show that the recto of the Abrams sheet was indeed "after nature," due to its similarity to an unpublished drawing in Copenhagen (Inv. no. Tu 42, 3b), with the same slightly decayed courtyard and house, from a different angle.

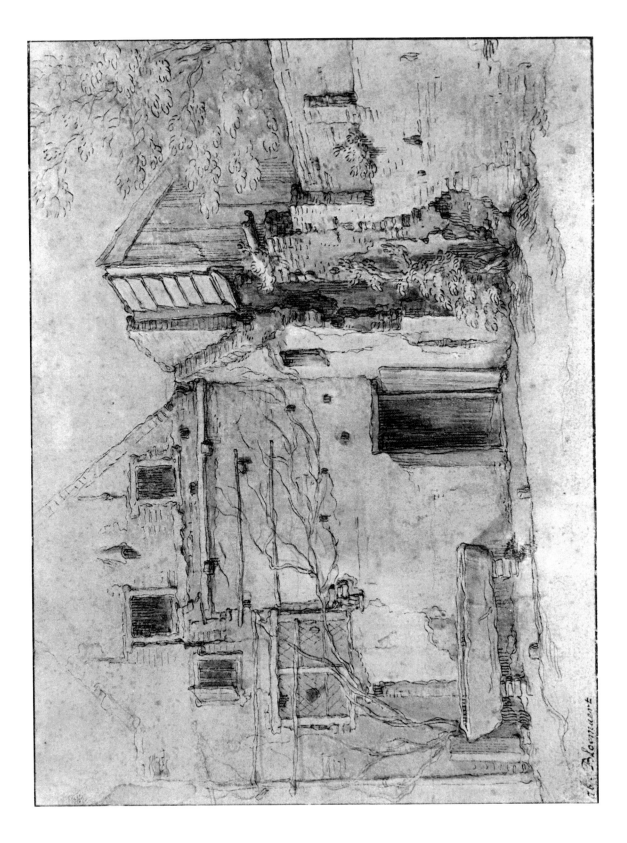

10 THREE STUDIES OF A YOUTH'S HEAD

Quill pen and brown ink, heightened with white, partly oxidized; border by another hand in pen and dark brown ink. Fragment of a watermark: fool's cap ? 5½ × 3¾.
Verso, in pen and light brown ink, *Jd Ghyn I*; in pen and dark brown ink, *b vag* (?) *5 ¾ / b* (?); in graphite, *N 31*.
PROVENANCE : Paul Brandt, Amsterdam; Dr. J.A. van Dongen.
LITERATURE : *Schilderijen, tekeningen en beeldhouwwerken. 16e – 20e eeuw. uit de verzameling van Dr. J.A. van Dongen*, Museum Willet Holthuysen, Amsterdam, 1968, no. 44, fig. 9.

Mr. and Mrs. George S. Abrams.

This brilliant drawing is by one of the most important Dutch mannerists. De Gheyn, the son and father of artists, was also the author of many engravings, and the engraver's technique may be seen in this drawing, with its overlapping systems of concentric curves for crosshatching and the use of dots for subtler areas of shadow.

J. Q. van Regteren Altena (letter, January 18, 1973) has pointed out that this drawing belongs to a group of similar sheets of the same dimensions, each of which contains two, three, or four heads of old men, old women, or boys, some of which are repetitions from other works. Professor van Regteren Altena further emphasizes the strong similarity between the boy looking upward, in this sheet, and the boy listening to his teacher in De Gheyn's painting of 1620, City of Manchester Art Galleries; he further points out that, although it is possible some of these drawings were executed by the artist's son, Jacques III, the quality of the best of them, as in the present case, must exclude Jacques III as the artist.

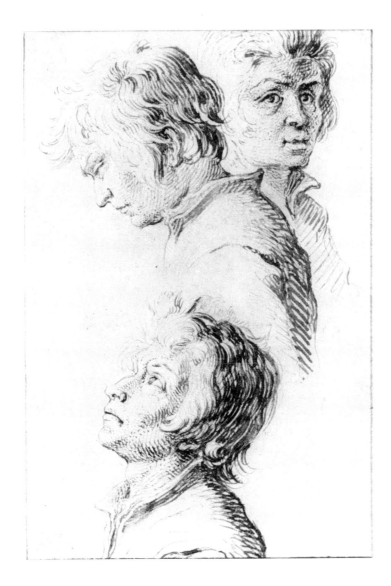

JACOB MATHAM *Haarlem 1571 – 1631 Haarlem*

11 HEAD OF A MAN

Black chalk, quill pen and brown ink, touches of brown wash, grey wash (added by a later hand?); border in grey wash, and, superimposed on it, another border in pen and black ink. The grey wash was added after the *H G* monogram, since the strokes are arranged around the letters. The four corners are restored; vertical and horizontal center folds. Watermark: fool's cap, with a *4* hanging from it, and three balls beneath the *4*, close to Churchill 355 (without *ID*); according to Churchill, datable to 1655. 11½ × 8½.

In pen and brown ink, *HG* (in monogram); in pen and dark brown ink (by a later, eighteenth century hand ?), *Goltzius*; in pen and brown ink, *No 624–11, ᵇ50ᵉ*. Verso, in pen and purple ink, *580* (under the *5*, in black chalk, *q*).

PROVENANCE: B. Houthakker.

Mr. and Mrs. George S. Abrams.

Jacob Matham was the student and stepson of the most brilliant Dutch mannerist draughtsman, painter, and printmaker, Hendrick Goltzius. The pen technique is typical of Haarlem mannerism and the Goltzius school in its calligraphic energy, swelling and tapering line, and "engraved" crosshatching, often with the addition of dots to suggest "lozenge and dot" engraving. Still more suggestive of his stepfather's influence is the remarkable similarity of this sitter to one of Goltzius's favorite models, Jan Govertsen, who appears in several of the older master's drawings and paintings. Goltzius, too, was interested in the bumps and knobs of an unusual face, as in his round etching of a similar head, Hirschmann 242.

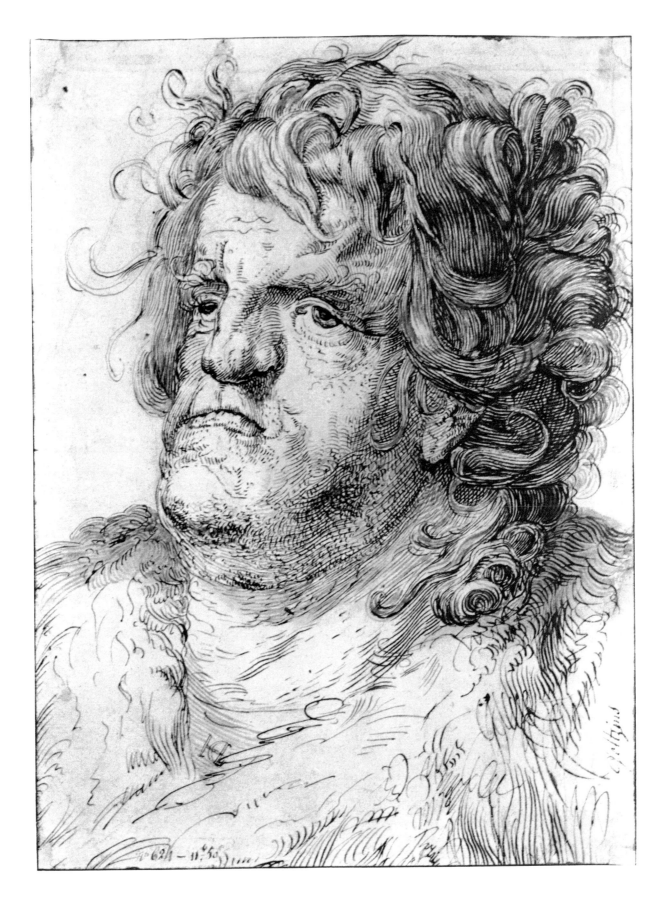

GIOVANNI FRANCESCO BARBIERI, IL GUERCINO
Cento 1591 – 1666 Bologna

12 THE REST ON THE FLIGHT INTO EGYPT

Quill pen and brown ink, brown wash, squared in black chalk (or graphite), on antique laid paper. Border in pen and black ink; marks of an earlier mat around the whole sheet. 9⁵⁄₁₆ × 14⅞.
Inscribed in an old hand, lower right, in pen and brown ink, *5* (or *3* ?).
PROVENANCE: Dan Fellows Platt.
LITERATURE: Ann Tzeutschler Lurie, "Guercino's Versions of the Rest on the Flight to Egypt and the Lancellotti Tondo," *Bulletin of the Cleveland Museum of Art*, February, 1970, pp. 96–97.
Mr. and Mrs. John Davis Hatch.

Guercino was one of several artists in the first half of the seventeenth century whose youthful style was deeply influenced by the naturalistic subject matter and strong contrasts of light and shadow characteristic of Caravaggio's paintings but who later became classical in style; in Guercino's case, this meant the Roman-Bolognese classicism of Annibale Carracci and especially Guido Reni. His numerous drawings are in, basically, two media, pen and ink and wash, and, on the other hand, red chalk. The pen drawings enjoyed a remarkable popularity throughout the seventeenth and eighteenth century, in Italy and also in England, and, like Salvator Rosa's, inspired many imitations and copies.

Although Guercino's drawings are often difficult to date with any precision, the present work, typical of the artist at his best with its easy integration of four figures and the donkey and its brilliant control of wash, is connected with a series of drawings related to a fresco of this subject, painted 1626–1627, in the Dome of the Cathedral of Piacenza (Lurie, pp. 96–98, and Denis Mahon, *Il Guercino. Catalogo Critico dei Disegni*, Bologna, 1968, nos. 106–108). The series of drawings recreates Guercino's thinking about this subject, from the first idea, in this drawing, of the Virgin and Child watching Joseph unpack a bundle as they stop for the night, to the final version, in the Piacenza fresco, of Joseph handing the baby to Mary as she unbuttons her dress to nurse him. This direct and unpretentious sensitivity to the life around him—a son offering his father a flower, shy, deformed faces, boys making fun of an insane man—is one of the most humane and appealing aspects of Guercino's work; Guercino himself was cross-eyed.

13 LANDSCAPE WITH A ROAD

Quill pen and brown ink, with touches of shading in graphite (by a later hand ?), on antique laid paper. $7\frac{9}{16} \times 9\frac{7}{8}$.
Inscribed by the artist in pen and brown ink, *C Vroom* (*C* and *V* in monogram) / *1631* (the border in pen and brown ink
obscures the lower loop of the *3*). Verso, engraved on an attached label, *Fuesli* / *pag* (in script), and an unidentified col-
lector's mark in black ink, *B* (in script). On the old mount, in an old hand, in graphite, *C. Vroom*; verso of the mount, in
pen and brown ink, *No. 8*, in graphite, *Larg. 9 p. 3 1. haut. 7 p.*

PROVENANCE: Karl U. Faber, Munich, 1972.

Mr. and Mrs. George S. Abrams.

This highly worked, tightly controlled draw-
ing, with its sharply differentiated bands of
light and shadow and pointillist foliage, is
typical of a certain tradition in Haarlem
landscape drawing which found its greatest
expression in the prints and drawings of Ja-
cob van Ruisdael. Although this style retains
some of the almost mannerist, restless callig-
raphy that characterizes the drawings of Jan
van Goyen and his followers as well, Vroom
and his followers lack Van Goyen's colloquial
intimacy and often emphasize a more power-
ful conception of nature, barren of human
beings. Vroom's influence can be most clearly
seen not only in drawings but in etchings by
his contemporary Jan van Brosterhuisen,
who also seems close to the prints of Hercules
Seghers and Willem Buytewech, and by such
later artists as Adriaen Verboom, Claes van
Beeresteijn, and Ruisdael.

JACOB JORDAENS *Antwerp 1593 – 1678 Antwerp*

14 THE ANNUNCIATION TO THE VIRGIN

Black and red chalk, graphite, pen and brown ink, brown and red ochre washes. The antique laid paper has been pieced on top and bottom; all three sheets have been laid down on another sheet, with a border in pen and black ink on this mount. 8½ × 6¼.

PROVENANCE: Sir Gilbert Lewis; Sir Henry Duff-Gordon; sale, Sotheby's, London, 1936; Geneviève Aymonier, Paris, 1946.

LITERATURE: Roger-A. d'Hulst, *De Tekeningen van Jacob Jordaens*, Brussels, 1956, no. 302, *Drawings from the Collection of Mr. and Mrs. Winslow Ames*, Providence, 1965, no. 50; Roger-A. d'Hulst, *Tekeningen van Jacob Jordaens 1593–1678*, Antwerp and Rotterdam, 1966, no. 98.

Mr. and Mrs. Winslow Ames.

This and the following drawing, by Lucas van Uden, are by artists who illustrate the deep impact Rubens had on seventeenth century Flemish art. Although Jordaens was a pupil of his father-in-law Adam van Noort, he sometimes worked up large paintings, with Anthony van Dyck, after oil sketches by Rubens, and after Rubens's death, completed several of his paintings left unfinished in his studio. In the 1640's, after the deaths of Rubens and Van Dyck, he came to be regarded as the first painter of Antwerp, and, in spite of his open Calvinism, received many commissions from Roman Catholic institutions. Although he lacks the elegance of Van Dyck and the intellectual range and power of Rubens, Jordaens has his own colloquial and convivial immediacy and, in general, lack of pretension; by the 1650's and 1660's, his importance had been recognized in the north

Netherlands, where he made major contributions to the two most important painting cycles of the Dutch seventeenth century, in the Huis ten Bosch and the Amsterdam Town Hall.

The present drawing, which, like so many of his works, has been pieced together from several sheets, is certainly after 1618, when he started using a wider variety of media, and may indeed be from the 1650's, with its less assertive figures and slightly awkward, wedge-shaped space (for a discussion of Jordaens's drawing chronology, see Carlos van Hasselt, *Flemish Drawings of the Seventeenth Century from the Collection of Frits Lugt*, London, 1972, pp. xxix–xxxvi). As usual, the drawing is wonderfully painterly and atmospheric, with only the angular strokes of the pen giving a positive definition to the Virgin and the angel.

15 LANDSCAPE WITH A RIVER AND BUILDINGS

Quill pen and brown ink, colored washes, and black chalk, on antique laid paper; laid down with a border in pen and black ink on the mount. Watermark of the mount: *AI.* 7⅝ × 13¹⁵⁄₁₆.
Signed in pen and brown ink, lower right, *Van uden.* Verso of the mount, in graphite, *35*, and marks of the Otto collection (Lugt 873b), the Knowles collection (Lugt 2643), and the Goldschmidt collection (Lugt 2926).
PROVENANCE: Rudolf Weigel; W. Pitcairn Knowles: Rudolf Philip Goldschmidt; E. J. Otto; Alfred Brod Gallery, London, 1963; Dutch private collection; R. M. Light, Boston, 1970.

Mr. and Mrs. George S. Abrams.

Lucas van Uden was perhaps the most gifted of the landscape draughtsmen in the circle of Rubens; he may have worked in the master's studio ca. 1615–1630 and his work remained under his influence for the rest of his career. The delicate modulations of tone in the colored washes in the sky, combined with a careful feeling for structure and detail in the trees, buildings, and ground, done in pen and ink, differentiate Van Uden's landscape drawings from those of such other members of the Rubens circle as Jacques d'Arthoys, Lodewijk de Vadder, and Jacques Fouquier.

Van Uden's drawings are rarely dated, and, thus, his chronology is still unclear. However, a similar, although smaller and tighter, landscape by Van Uden in an *Album amicorum* is signed and dated 1648 (Frederick Lina, "Uit het Album Amicorum van Philip van Valckenisse," *De Kunst der Nederlanden*, I, 2, Aug. 1930, p. 73); the present sheet represents the artist at his best and is comparable to similar drawings by him, for example, in the Louvre (Lugt 1355) and in the National-museum, Stockholm, with identical dimensions.

16 MOUNTAINOUS LANDSCAPE

Pen and brown ink, brown wash, touches of grey wash, black chalk, on antique laid paper. 5⅞ × 9.
Signed, in pen and brown ink, *R Roghman*.
PROVENANCE: Dr. Curt Otto, Leipzig; C. G. Boerner, Leipzig, 1929; P. and D. Colnaghi, London, 1969.
Mr. and Mrs. George S. Abrams.

Roelant Roghman is one of the most remarkable draughtsmen from the circle of artists around Rembrandt, with whom he was, reportedly, close friends. Roghman's drawings differ from those of other Rembrandt followers in their emphasis on mountain landscapes, perhaps a reminiscence of his trip to Italy in 1640, and are, perhaps, closest to Lambert Doomer's somber, brooding views of dunes and rivers, rather than Philips Koninck's more rectilinear, flatter landscapes or Anthonie van Borssum's more colloquial, intimate views of cows in a meadow or windmills by a canal. Roghman's hand may be seen here in the spontaneity and freedom with which he builds up the boulders in the left foreground, suggests the sudden burst of light in the middle ground, and places, as he often does, a single figure, dramatically alone, in this romantic setting.

LAURENT DE LA HIRE Paris 1606 – 1656 Paris

17 THE PRESENTATION OF CHRIST IN THE TEMPLE

Black chalk, graphite, and grey wash; border in pen and black ink. Slight foxing. 17¹¹⁄₁₆ (from the top of the arch to the bottom edge) × 11⅞₆.

Inscribed by the artist in graphite, —— (*pour?*) *Raison*; inscribed by a later hand in pen and brown ink, *La Hire*. Marks of an unidentified collection (*P B* with a crown above, in reddish brown), the Van Suchtelen collection (Lugt 2332), and the Damery collection (Lugt 2862). Verso, in pen and brown ink, in an old hand, —— *genault*; in pen and brown ink, *Damery | 1757*; mark of the Held collection (H, J, and S in monogram, in black ink). On the old mount, mark of the Graaf collection (Lugt 1120), and inscriptions referring to Damery, Van Suchtelen, and J. B. Glowry; verso of the mount, mark of the Held collection.

PROVENANCE: Chevalier de Damery; J. B. de Graaf; Count J. P. van Suchtelen; sale, Dorotheum, Vienna, June 2, 1964, no. 270, reproduced, pl. 92.

LITERATURE: *Selections from the Drawing Collection of Mr. and Mrs. Julius S. Held*, Binghamton, 1970, no. 62.

Professor and Mrs. Julius S. Held.

This unusually large and complete drawing is an example of the draughtsmanship of one of the most sensitive and appealing of the French classicists of the 1640's. La Hire began as a student of Lallemand and studied the mannerist decorations at Fontainebleau; however, beginning in the early 1640's, he came more and more under the influence of Poussin and it is to this last decade or so of his life that this beautiful drawing must be assigned. Such a work is perhaps more delicate and attractive than what must surely be the most monumental drawings of his career, the two series in the Louvre of the Apostles and of the life of St. Stephen, which also are set in classical architecture.

La Hire made another drawing of the same subject and precisely the same composition, in the Louvre (Guiffrey and Marcel, no. 5567); the Louvre version, which seems slightly later, is larger than the present drawing and stiffer in execution. These drawings are clearly related to a painting in the Held collection by La Hire, of the same subject but now clearly out-of-doors and on the steps of the temple.

The difference between La Hire's later work and his style of the 1630's may be seen by comparing the present drawing with one of a similar subject, the *Presentation of the Virgin*, in the British Museum, a preparatory study for a painting, formerly Youssoupof collection, dated 1632. Although the earlier drawing is also arched and set in classical architecture, the broader strokes, less attention to detail, more overt emotion, and elongation of such details as fingers and hands show that it is closer to La Hire's mannerist origins. The style of the present drawing is close, for example, to a *Virgin and Child* in the Hessisches Landesmuseum, Darmstadt, datable to 1642.

48

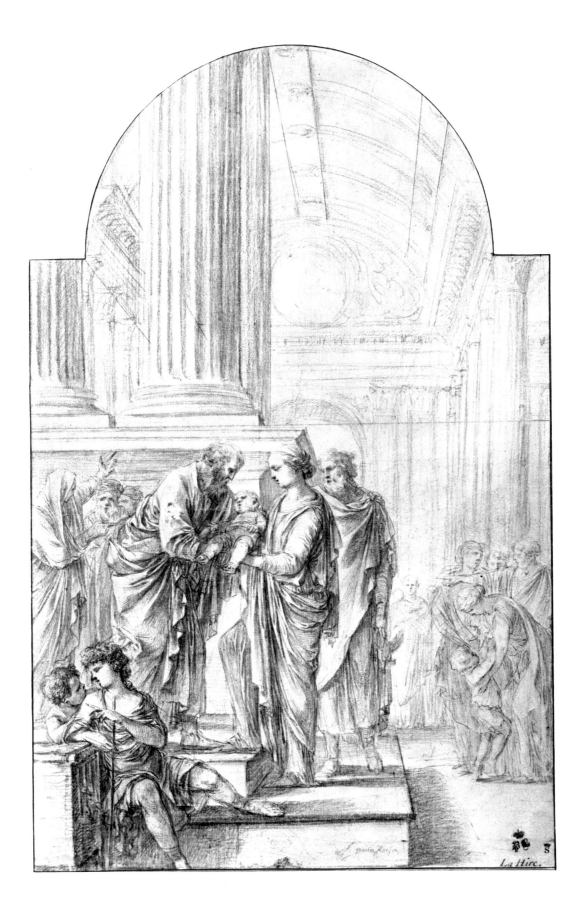

La Hire.

REMBRANDT HARMENSZ. VAN RIJN *Leiden 1606 – 1669 Amsterdam*

18 JOSEPH TELLING THE DREAMS OF THE BUTLER AND THE BAKER

Brown ink with quill and reed pens and brown wash on cream antique laid paper; outlined in pen and brown ink. Watermark: long doubleheaded eagle, each head crowned (Heawood 1302, Holland 1635; Heawood 1303, Amsterdam, 1644). $6\frac{1}{16} \times 7\frac{3}{16}$.

PROVENANCE: Joachim von Bergmann, Störkel-Kauffung, Silesia; A. S. Drey, Munich, July, 1927.

LITERATURE: Otto Benesch, *The Drawings of Rembrandt*, London, 1954–1957, 1, no. 109, fig. 124; E. Haverkamp-Begemann and Anne-Marie Logan, *Rembrandt After Three Hundred Years*, Art Institute of Chicago, 1969, no. 104, pp. 162–163 (for further bibliography and exhibitions, see this entry).

Anonymous lender. *J-M. Brown*

This masterpiece shows Rembrandt at his most High Baroque, in the middle 1630's. The drawing shows the scene from Genesis, where Joseph, thrown in jail by Potiphar, interprets the dreams of the butler, who will be restored to the Pharaoh's favor, and the baker, who will be hanged in three days.

Another, slightly earlier version of the same subject, in the Art Institute of Chicago, offers a striking comparison. In many ways, the two drawings are similar; in each, Joseph stands to the left, and his two listeners sit on the right, with parts of the prison architecture quickly sketched in above them. In each, Joseph is bareheaded, the baker wears a kind of beret, and the butler has a marvelous feathered hat. However, in the present drawing, the three figures form a dynamic group, with Joseph gesturing dramatically, his feet placed firmly apart, leaning to the center, while the butler leans intently forward, staring; in the center, the baker writhes in anguish, his hands are clasped together, and he seems in the act of rising from his seat. In addition, Joseph is now radiant, on both left and right, with the light of divine prophecy,

and there is a trace of an arch framing him. This seems a happier solution to the difficult problem of unifying a group of three figures, all of them essential to the scene, but only two of whom actually react to each other at this point in the story. The Chicago drawing, excellent though it is, is less unified, less clear in its contrast of divine light and tragic shadow, and in its delineation of the emotions, and fates, of the actors; and the figures are less surely placed within the rectangle of the paper. This constant return to a theme, in an attempt to perfect it, is typical of Rembrandt throughout his career.

A drawing of the same subject by Ferdinand Bol, in the Kunsthalle, Hamburg, shows Rembrandt's student trying to solve the same problem of a composition of three figures, one of whom is not intimately involved in the action. Bol's solution is to push the listening butler close to the figure of Joseph, subordinating him to the basic confrontation between Joseph and the anguished baker, whose pose is somewhat similar to the baker's in the present sheet.

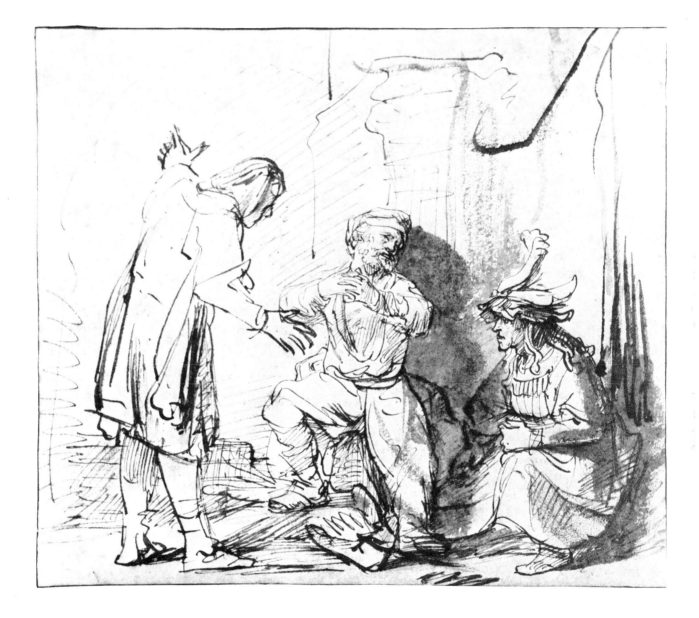

STEFANO DELLA BELLA *Florence 1610 – 1664 Florence*

19 ALLEGORICAL FIGURE

Brown, iron gall ink over black chalk, with grey wash; laid down. Seemingly random lines along the right edge may indicate the drawing has been cut down on this side. 7⅛ × 5⅝.
Blind stamp of the Ames Collection (*w*+ /*aa*).
PROVENANCE: Colnaghi's, London, 1964.
LITERATURE: *Drawings from the Collection of Mr. and Mrs. Winslow Ames*, Providence, 1965, no. 6, as Boreas.

Mr. and Mrs. Winslow Ames.

This small, dynamic drawing is typical of the work of this master, a printmaker who was interested in everything from ostriches and elephants to sea battles to court festivals. Born in Florence, Della Bella's style for the earlier part of his career was profoundly influenced by Jacques Callot, the great French etcher who had also worked in Florence. From 1639 to 1650 Della Bella lived in Paris, enjoying considerable success; at this time, he became more and more influenced by contemporary Dutch printmakers, particularly Rembrandt but also Jan Both and Bartholomaeus Breenbergh, and in 1647 he visited the Netherlands. In 1650, he returned to Florence where, with some trips within Italy, he remained for the rest of his life.

The subject of this drawing is difficult to determine; it has been identified as Boreas, the north wind, and certainly the general air of frenzy makes this identification reasonable. The figure also is close to a drawing of Narcissus in the Uffizi (no. 8120F), and the pose is similar to that of a satyr in one of his etchings (Alexandre de Vesme and Phyllis Dearborn Massar, *Stefano della Bella*, New York, 1971, II, no. 746, p. 144). However, the drawing is closest to a remarkable series of etchings of the *Six Deaths*, the first five of which were made in Paris in the 1640's and the sixth the last year of his life, completed by his student, Gian Galeazzo Galestruzzi. The present drawing, in an oval and with a sinister, skeleton-like head to the left, is close to the preparatory studies for the last etching, the *Sixth Death*, in the Kunsthalle, Hamburg (Françoise Viatte, "Stefano della Bella: 'Le Cinque Morti,' " *Arte illustrata*, no. 49, June, 1972, p. 206, figs. 10 and 11). Certainly, Della Bella's images of death in his various etchings, with the skeleton carrying off a screaming child or riding on horseback across a battlefield, are among his most powerful works; the fact that the artist envisioned a long series on the theme, in the manner of Holbein in particular, is shown by his very different, austerely linear drawings, in pen and ink, in the Albertina (Stix and Fröhlich-Bum, nos. 608–614).

20 VENUS AND MARS. Verso: sketches in black chalk of a man's right arm, a putto's head, and a mouth(?).

Red chalk on white antique laid paper. Watermark: a crown surmounted by a six-pointed star and the initials *G.B.* It is similar to Heawood 1116–1122, which are Italian watermarks found in Rome and Venice in the second half of the sixteenth century and the first third of the seventeenth, but without the initials. 6½ × 9⅛.
Upper left, in pen and brown ink, *n* (?) *553*.
PROVENANCE: C. G. Boerner, Düsseldorf.

Mr. and Mrs. Paul Bernat.

This fresh and intimate drawing epitomizes some of the most appealing aspects of a major school of seventeenth century Italian art, the Roman-Bolognese classicists. Annibale Carracci, the most brilliant and influential of these artists, created at the beginning of the century a more open, even playful, baroque version of the High Renaissance forms of Raphael and Michelangelo, and it is this relaxed, yet powerful classicism that Simone Cantarini is responding to in this drawing, with its unpretentious spontaneity and frank sensuality.

Cantarini was the student—and rival—of Guido Reni, a follower of Annibale whose magnificently intense, aloof, sublime compositions were the major immediate influence on Cantarini; the latter made a variant of Reni's famous *Aurora* and also a sensitive portrait of the old painter, both in the Pinacoteca Nazionale, Bologna. Cantarini, however, is perhaps best known for his etchings, with allegorical or religious subjects, often the *Rest on the Flight*, set in a fresh and leafy landscape. It is through Cantarini's etchings, and those by other Roman-Bolognese artists, such as Grimaldi, Torri, and Elisabetta Sirani, with their light-filled compositions and open hatching, that the Bolognese style came to be spread throughout Europe; it is possible, for example, that some of Rembrandt's etchings of the 1650's were responding to Cantarini's prints.

Cantarini's drawings are numerous, and the present work is close to many others in red chalk; those in pen and ink seem to be even more open and free. He often portrays Venus, with Adonis or Mars (Andrea Emiliani, *Mostra di disegni del Seicento emiliano nella Pinacoteca di Brera*, Milan, 1959, no. 55), and he executed an etching, in a vertical format, after a *Venus and Mars* by Veronese. Certainly, this format of a nude lying on the ground is reminiscent of Venetian models; a putto pulls back the curtain to reveal the dawn and a Carraccesque landscape beyond, as a masculine figure, perhaps Mars, is still drowned in sleep on the left. Cantarini placed his figures within his own border more than once (see the *Woman and Child* [*Sibyl?*], Windsor Castle, Kurz, no. 45). The brevity of Cantarini's life makes the task of establishing a chronology for his drawings a difficult one; certainly, the crosshatching around the figure's neck and elsewhere suggests the artist has already become involved in printmaking. (For another, very different drawing by a seventeenth century Bolognese artist, see no. 12, by Guercino.)

21 MILO OF CROTONA

Brown ink with quill pen and brown wash on cream antique laid paper. The tree trunk has been heightened with lead white and the left foot corrected in lead white, perhaps by a later hand. The pigment has discolored to black. The fore-arm and abdomen outline have been retouched with graphite. Watermark: circular, but illegible in detail. There is extensive insect damage (prior to mounting) at the right and upper edges. The central design is intact. The drawing is mounted on an elaborate seventeenth (or eighteenth) century framing mount with decorative molded and rinceau borders in brown ink and wash centered at the lower edge by a large Medusa head. The mount has been cut at the top. 12¾ × 8¾.

Lower left, in pen and brownish-black ink, SALV:ROSA. *1614–1673*; lower right, in the same hand and medium, MILO; lower left, in pen and brown ink, *from vol I V:I No 38*. Lower right, in black, stamp of the Russell collection, Lugt 2770a.

PROVENANCE: Earl of Pembroke; sale, Sotheby's, London, July, 1917, no. 516; A. G. B. Russell; Sotheby's London, May 22, 1928, no. 81 (illustrated).

LITERATURE: "Drawings in the Collection of Mr. Archibald G. B. Russell," *Connoisseur*, May, 1923, p. 8; A. Strong, *Drawings by Old Masters at Wilton House*, pt. I, pl. 10; Burlington Fine Arts Club, 1925, cat., p. xxxviii; Magnasco Society, 1927, no. 12; exhibited, Wadsworth Atheneum, Hartford, 1930; Michael Mahoney, *The Drawings of Salvator Rosa*, Courtauld Institute of Art, 1965, unpublished dissertation, no. 79.6.

Anonymous lender. G. N. Brown

This masterpiece by the Neapolitan painter and graphic artist shows Milo, a great Olympian wrestler of the sixth century B.C., who tried to tear a tree apart with his bare hands, was caught in the cleft and eaten by wolves. Rosa must have been attracted to the story not only for its violent melodrama but for its suggestion of genius reaching beyond itself and being destroyed. The subject was treated fairly often in sixteenth and seventeenth century Italian art; Klaus Herding (*Pierre Puget*, Berlin, 1970, figs. 181–184) shows that Alessandro Vittoria, Annibale Carracci, and Francesco Maffei had all dealt with this aspect of Milo's life. However, none of these is close to Rosa's marvellous conception, and it seems to have been original with him. Although no painting by Rosa of this subject seems to have survived, it is difficult to believe that Rosa's image was not a major inspiration for Pierre Puget's magnificent sculpture of Milo, 1671–1682, in the Louvre, an hypothesis reinforced by his drawing in Rennes (Herding, fig. 177), which is done almost completely in wash and has all the freedom and spontaneity of Rosa's

drawing (in contrast to his more careful chalk study in Montpellier, Herding, fig. 178). Although Rosa has both of Milo's hands caught in the cleft, and Puget only one, the contorted face and intensity of the whole pose suggest a connection between the two works. Certainly, Puget's interest in contemporary Italian art, such as the works of Castiglione and Della Bella, can be clearly documented.

Michael Mahoney (letter, April 6, 1973) has pointed out the existence of at least three other sheets by Rosa of this subject, one a very free sketch recently in the London trade, a second, a similarly free sketch in the Louvre, no. 9731, and a black chalk drawing in the collection of Alex Bibson, Toronto, dealing with the same problem of the placement of the foot as the present sheet. On stylistic grounds, he dates this drawing to the mid-1660's. The impact of the drawing is enhanced by the elaborate baroque framing mount that still surrounds it. Still another drawing of the subject is in the Metropolitan Museum (letter from Jacob Bean to the collector, February 2, 1967).

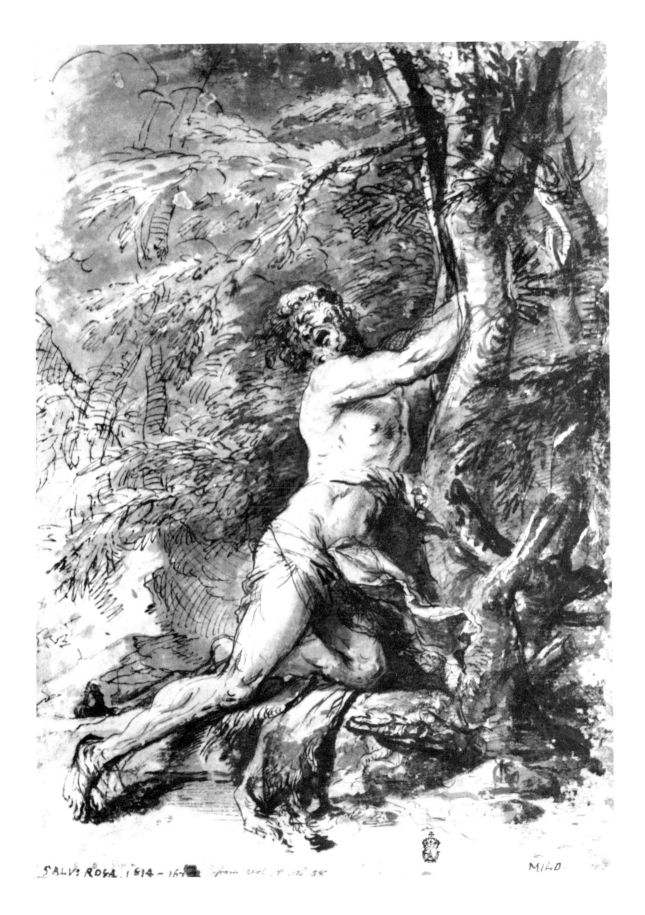

SALV: ROSA. 1614 - 167 from vol. 4 no 38 MILO.

22 TWO HEADS

Black chalk and graphite on parchment. All corners but the upper right one have been clipped. Verso: traces of glue from an old mount. 3³⁄₁₆ × 5.
Verso, in graphite, *W. 8603*.
PROVENANCE: Faerber and Maison, London, 1966; Dr. J. A. van Dongen.

Mr. and Mrs. George S. Abrams.

In many respects, Gerard ter Borch seems to have been the creator of the new approach to genre subjects, and to the world of women, that appeared in Dutch painting in the 1650's and 1660's. His work, which in the 1630's showed quiet soldiers playing cards or smoking, now is characterized by quiet women, often accompanied by subordinate men or watched by attentive children, as they peel an orange or read a letter.

Ter Borch's drawing style is still in the process of definition. Those works which are most clearly his—the *Sleigh* or the *Mounted Woman*, both in Amsterdam—represent unusual subjects for the master. Fewer drawings survive that can be directly connected with his most beautiful paintings, the views of elegant ladies in well-appointed quarters, just before and after 1660. Perhaps the frequency with which he repeated his models and settings made preparatory drawings unnecessary. Nevertheless, the delicacy and understated openness of the handling of the chalk here is reminiscent of his signed works, and the subjects themselves, both with their eyes averted, are typical of the master's paintings, such as the *Woman Sewing*, private collection, Aerdenhout (Gudlaugsson 115), the *Boy Fleaing a Dog*, Alte Pinakothek, Munich (Gudlaugsson 116), and the *Woman Peeling an Apple*, Kunsthistorisches Museum, Vienna (Gudlaugsson 167).

The present drawing, on vellum, has the exquisiteness of touch of a silverpoint by a fifteenth- or early sixteenth-century master, such as Gerard David.

EUSTACHE LESUEUR *Paris 1617 – 1655 Paris*

23 THREE CARTHUSIAN MONKS

Black and white chalk, touches of graphite, on tan antique laid paper; laid down. 9$\frac{15}{16}$ × 16$\frac{3}{16}$ (irregular).
Blind stamp of the Ames Collection ($w + /aa$).
PROVENANCE: G. Fenwick Owen; sale, Sotheby's, London, February 16, 1949; Colnaghi's, London, 1949.
LITERATURE: *Drawings and Watercolors from Alumnae and their Families*, Vassar College, 1961, no. 48; *Drawings from the Collection of Mr. and Mrs. Winslow Ames*, Providence, 1965, no. 63.

Mr. and Mrs. Winslow Ames.

Eustache Lesueur, like Laurent de La Hire, is another example of the impact of Poussin's classicism in seventeenth-century France. A student of Vouet, he collaborated with Philippe de Champaigne and Sébastien Bourdon and, in the last years of his short life, worked almost exclusively for ecclesiastic communities.

This drawing, notable for its sober, unpretentious, almost anonymous piety, is one of his many studies for his masterpiece, a series of twenty-two paintings, done between 1645 and 1648, depicting the life of St. Bruno and the founding of the Carthusian order. Although other artists, such as Champaigne and Andrea Sacchi, depicted scenes from the life of St. Bruno, Lesueur's series, now in the Louvre, was regarded by the Carthusians themselves as the most faithful record of the spirit of their order. The drawings for the paintings, most of which are now in the Louvre, can be divided into two types: the first thoughts for a subject, set down in wash, and more careful figure studies, done in black chalk, of which the present drawing is an example. The monks' voluminous robes almost seem an emblem of their humility, and the understated draughtsmanship is emphasized only here and there, for example, in the line of a foot pressing down on a spade; the three activities represented here, reading, praying, and working, sum up much of their ritualized lives.

24 LANDSCAPE WITH HOUSES

Brown ink with quill pen, brown wash, and perhaps a touch of white gouache in the building at the right, on cream antique laid paper; laid down on an old mount. There is a small repair in the sky at the upper left. 6 × 9¾.

Mr. Eric H. L. Sexton.

Philips Koninck is one of the most important painters and draughtsmen in the circle of artists around Rembrandt. His drawings are characterized by a strong emphasis on the flat landscape contrasted with the strong verticals of such elements as trees; although his views generally show a panorama from a slightly higher vantage point, his etchings, like the present drawing, present closer views of houses, farms, or canals at eye level. The large city in the background, which may also be seen in the break between the trees on the far left, is probably Amsterdam.

Part of the difficulty in attributing drawings to Koninck is the fact that other members of his family, notably Jacob, also execute landscape drawings and prints under Rembrandt's influence, as do many other contemporaries, for example, his brother-in-law Abraham Furnerius.

25 ELIJAH AND THE PROPHETS OF BAAL

Brown ink with quill pen and brown and grey wash on cream antique laid paper. Watermark: L (B?) D. 8⅛ × 12¾. In pen and brown ink, redrawn in pencil, lower right, *WE* (Lugt 2617); lower right, a printed pasted label, *Acquis de M. Defer* (Pierre Defer, then Henri Dumesnil; see Lugt 739). Verso, in pen and brown ink, *JB* (probably J. Barnard, Lugt 1419); in brown ink, *M Gersaint* / (-?-) /*Rue Depont*; in brown ink, *29 P. 7;* in brown ink, *X.A.D.* (A. Donnadieu, Lugt 2666); in brown ink, *WE p. 91.1811* (Esdaile; see above); in brown ink, *16 —* (crossed diagonal cipher) / *wyo* (in monogram) (W. Y. Ottley, Lugt 2662); stamp in brown ink, *M.J.P.* in cartouche (M. J. Perry, Lugt 1880); in pencil, *Horace Walpole's "Strawberry Hill" Collection (sold in 1842)* / *Collection of Wm Young Ottley* / *Keeper of prints in the British Museum* / *author of Ottley's facsimiles of rare prints* / *John Barnard Collection* / *Esdaile collection*; pencil, by another hand, *M Defer Collection*; in pencil, *Strawberry Hill Collection* / (-?-) / *Study for the famous picture* (-?-) / *Rembrandt van Rhyn 1651*; in pencil, *Lord James Burton. Coll. 1842* / *Paris sale of Dufresnoy* (?); in pencil, *Elijah and the Prophets of Baal* / *I Kings xviii, 22–39;* in pencil, *HNX^{rx}* (perhaps H. Walpole, Lugt 1386); black stamp on a separate piece of paper affixed to the verso, double circle ¼ inch in diameter, reading *PARTIOREDE* (-?-) *ST* (-?-).

PROVENANCE: W. Esdaile; Berlant; Gersaint; John Barnard; James Butler; Dufresnoy; Lord James Burton; W. Young Ottley; Horace Walpole; Captain Donnadieu; Defer-Dumesnil; Marsden J. Perry, Providence; Joseph E. Widener, Elkins Park; W. R. Valentiner, Berlin/Raleigh.

LITERATURE: (*Rembrandt Drawings in the Collection of Joseph E. Widener, Volume of Photographs*, ca. 1921), pl. 32; H. Gerson, *Philips Koninck*, Berlin, 1936, z.129; E. Haverkamp-Begemann and Anne-Marie Logan, *Rembrandt After Three Hundred Years*, Art Institute of Chicago, 1969, no. 185, p. 195.

Professor and Mrs. Seymour Slive.

E. Haverkamp-Begemann and Anne-Marie Logan (*Rembrandt After Three Hundred Years*, Chicago, 1969, p. 196) have pointed out that this representation of the victory of the true over false religion—the kneeling Elijah's prayers ignite the offering on the altar, while the efforts of King Ahab, in the center, and the prophets of Baal have failed—is based on a drawing by Samuel van Hoogstraeten, in the British Museum, H. I, or perhaps on a model that Hoogstraeten himself may have used. Koninck's remarkable ability to simplify to the essentials may be seen by comparing the bald figure, looking down, on the left of the central group with a similar figure in an earlier, and more detailed, pen and wash drawing by Koninck, dated 1668, in the Abrams collection (*Dutch Drawings from the Abrams Collection*, Wellesley, 1969, no. 13). Insofar as this work is based on models by Rembrandt, it must be the Rembrandt of the 1640's and early 1650's, when he takes the basic structure of the *Nightwatch* of 1642—a core of figures with wings of figures on either side—and turns it inward, making it more introspective and less overtly dynamic, as in his etchings, the *Presentation in the Temple* of ca. 1640, the *Hundred Guilder Print*, and the *Petite Tombe*.

This drawing is also unusual with respect to its provenance; more than a dozen owners are known, including a few, like William Esdaile, who are among the greatest drawing collectors.

26 VIEW OF THE RHINE VALLEY WITH AN UNIDENTIFIED VILLAGE WITH TWO SPIRES. Verso: View from the "Galgenberg" near Cleves on a small part of the town wall and the "Heideberger" mill outside.

Graphite, black chalk, and grey wash on cream antique laid paper. Fragmentary watermark: upper part of a crowned coat of arms, perhaps comparable to Churchill 427. $5\frac{3}{16} \times 9\frac{1}{4}$.
Signed in black chalk, lower left, *A Cuyp*; verso, inscribed in graphite, *Coll. ten Cate 196*.

PROVENANCE: H. E. ten Cate, Oldenzaal; C. G. Boerner, Düsseldorf (1964); R. M. Light & Co., Boston.

EXHIBITIONS: B. Houthakker, Amsterdam, 1952, no. 15; C. G. Boerner, Düsseldorf, *150 Meisterzeichnungen*, no. 13, illustrated.

LITERATURE: I. Q. van Regteren Altena, *Dessins de Maîtres Hollandais du 17ième Siècle*, no. 32; D. Hannema, *Collection of H. E. ten Cate*, Oldenzaal, 1955, no. 196, fig. 98.

Anonymous lender. *CCC*

This sheet belongs, stylistically, technically, topographically, and in size, to a group of landscapes and townscapes which Aelbert Cuyp drew in the area of Nymegen-Cleves on a journey in 1651–1652. The undersigned have been able to reconstruct one or two sketchbooks which Cuyp filled on this journey (unpublished). The size of Cuyp's sketchbook did not fit completely with the small long views he wanted to draw. Thus, Cuyp continued towns and landscapes which he drew on the recto of a sheet to the left on the verso of the previous sheet. This is the case with the drawing on the verso of the sheet with which we deal here: the drawing on the verso is the continuation of a *View of Cleves* in Chantilly, which was originally the next sheet in the same sketchbook as our sheet.

The date for Cuyp's journey is deduced from dateable architectural details in townscapes which belonged to the same sketchbook.

All paintings which are based on drawings from this journey cannot have been painted before 1651. This holds true also for the group of paintings with views of Elten, one of which was in the exhibition *Aelbert Cuyp in British Collections* (National Gallery, London, 1973), no. 7, there erroneously dated about 1648–1650.

J. G. VAN GELDER AND INGRID JOST

ABRAHAM RUTGERS *active ca. 1660 – 1700*

27 THE RIVER VECHT, NEAR MAARSSEN

Graphite, quill pen and brown ink, brown wash; border drawn by the artist in pen and brown ink, with a ruled graphite line on the right edge. Verso, on right edge, vestiges of several old hinges (including indications of detachment from a notebook?). Watermark: fleur-de-lys (cut off at the top). 4⅜ × 8¹⁄₁₆.

Verso, in graphite, *Een Gezigt aan de Rieveir den Vegt | omtrent Maarsen door Am Rutgers 1690*; in graphite, in another hand, *A. Rutgers.*

Mr. and Mrs. George S. Abrams.

Little is known of this rare artist. He worked mainly in and near the city of Utrecht and may have been the student of the marine painter Ludolf Backhuysen.

His drawings, although rare, are distinctive. They combine a handling of pen and wash reminiscent of such Rembrandt followers as Van Borssum and Furnerius with the clarity of space and reticence characteristic of a number of draughtsmen centered in The Hague, such as Jan de Bisschop, Constantijn Huygens, and Josua de Grave. Rutgers emphasizes the extreme flatness of the Dutch landscape, often adding a canal cutting diagonally into the background; when there are figures, they are usually seen from the back, as in the present drawing, in which a man seems to be pulling a boat or a barge. The views are, as a rule, precisely identifiable, although they were, evidently, not intended as preparatory studies for prints or paintings, only one of which is extant.

28 A YOUTH WITH A FIFE

Black and white chalks on tan antique laid paper. The drawing has been cut vertically approximately 1½ inches from the right edge. The pieces have been restored and the sheet entirely adhered to a second sheet. The drawing's surface is somewhat rubbed. 15⅜ × 12.

PROVENANCE: Acquired, Aix-en-Provence, ca. 1950.

Miss Agnes Mongan.

Giambattista Piazzetta was one of the major figures of early eighteenth century Venetian painting and strongly influenced the early work of Giambattista Tiepolo, a drawing by whom follows those by Piazzetta in this catalogue. He studied under Giuseppe Maria Crespi in Bologna and was deeply influenced by the strong chiaroscuro not only of Crespi but of an earlier Bolognese artist, Guercino.

Piazzetta's drawings were finished works of art in their own right and were admired and prized already in the eighteenth century; although he made many drawings, particularly in the 1740's, connected with his book illustrations for Albrizzi's edition of Tasso's *Gerusalemme liberata*, which are surprisingly French, rococo, and airy, it is these monumental busts that most appealed to contemporary collectors. The subjects of these remarkable studies range from old men to Levantines to St. Theresa; however, his favorite subjects are a boy or a girl holding some everyday object. Another drawing by Piazzetta, in the Castello Sforzesco, Milan (*Giambattista Piazzetta e l'Accademia, Disegni*, Milan, 1971, no. 5) also shows a boy with a fife but is more linear and less monumental. Piazzetta's drawings are difficult to date, since the great majority of these busts are so similar in style; certainly, they accord well with his one dated drawing, his magnificent self-portrait in the Albertina, from 1735. As often happens with Piazzetta, an extra sheet has been added on the right.

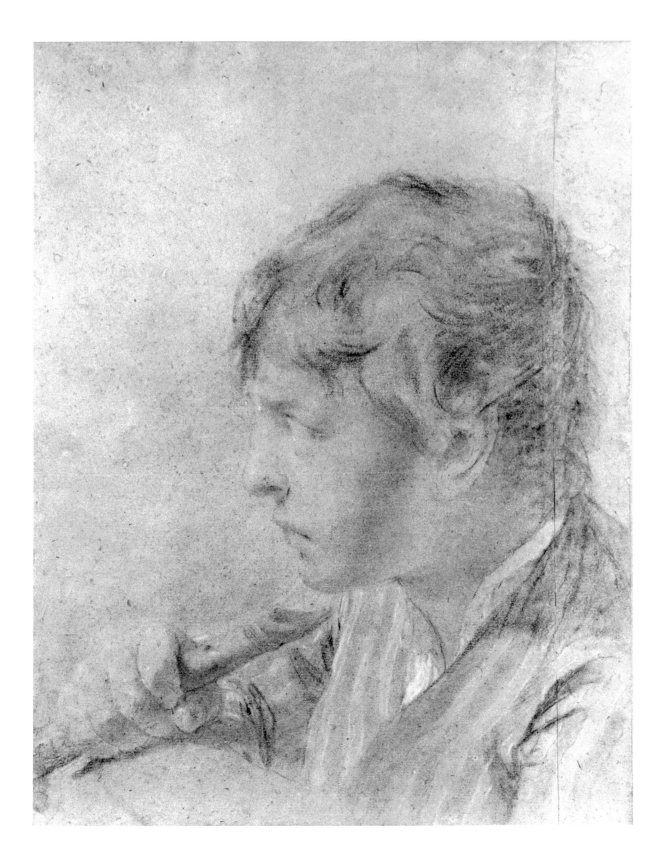

GIAMBATTISTA PIAZZETTA *Venice 1682 – 1754 Venice*

29 A GIRL HOLDING AN APPLE

Black and white chalk on tan (originally blue) antique laid paper. The paper has not been pieced on the right edge, but there is a dark line (in black chalk?) 1½ inches from the right edge and parallel to it. 15¾ × 11⅝.
Blind stamp of the Ames Collection ($w+/aa$).
PROVENANCE: G. Fenwick Owen; sale, Sotheby's, London, February 16, 1949; Colnaghi's, London, 1949.
LITERATURE: *Drawings from the Collection of Mr. and Mrs. Winslow Ames*, Providence, 1965, no. 71.

Mr. and Mrs. Winslow Ames.

This is a particularly well-preserved example of Piazzetta's powerful drawings in black and white chalk of young women, filling the sheet. Piazzetta often portrayed a boy or a girl with a piece of fruit in his hand, as in the painting of a boy with a pear, in the Wadsworth Atheneum, Hartford, or a girl with a pear, a drawing in the Morgan Library, New York. In the latter case, it may be that this is from a series of the five senses (Jacob Bean, Felice Stampfle, *Drawings from New York Collections*, III, *The Eighteenth Century in Italy*, New York, 1971, no. 42); clearly, Piazzetta often uses jingle rings or flowers or fifes as props, and sometimes may even be making a contrast between a young man with a bag of coins and another with a book (in the Accademia, Venice). Although the two drawings by Piazzetta in this exhibition are surely not pendants, once again each holds an object that can be clearly associated with one of the senses.

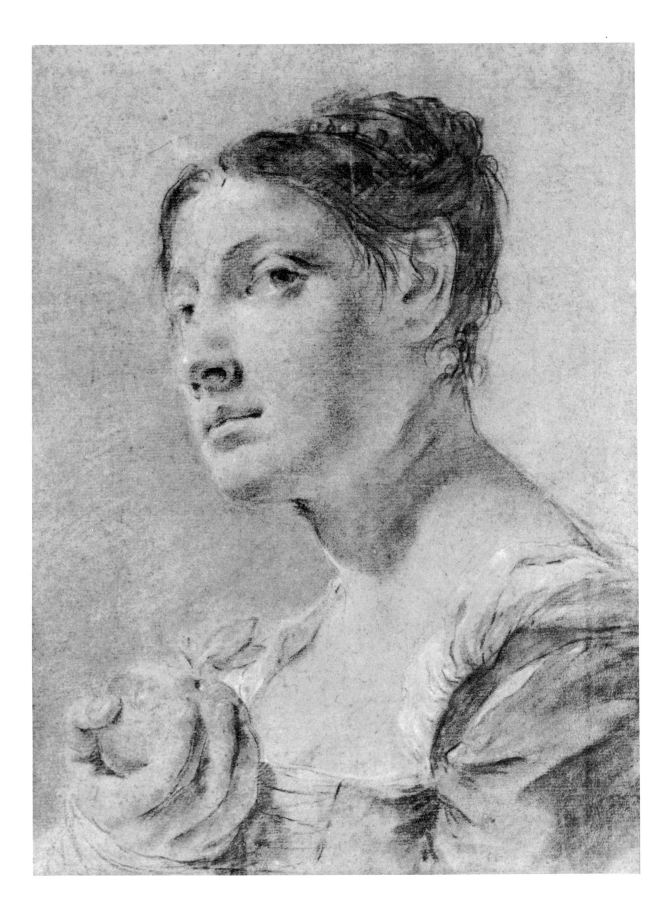

30 STANDING MAN

Black chalk, brown ink with quill pen, and brown wash on cream antique laid paper; there is a border in graphite at the top, bottom, and right sides. Lightly foxed and laid down on an eighteenth-century mount. 7¾ × 5¾.

Anonymous lender. *John Constable*

Giovanni Battista Tiepolo was the "presiding genius" of eighteenth century Venetian painting, covering vast canvases and frescoes, ceilings and walls, with visions of a light and airy world whose actors effortlessly changed roles from Biblical characters to allegorical or mythological figures to heroes and heroines from Italian epic poetry to spectators at a royal wedding or procession. Besides Venice, Tiepolo worked in Würzburg and Spain and made numerous drawings, usually in black and white or red chalk or, as here, in pen and ink and wash.

This brilliant little sketch, in which the washes around the right arm and the front of the figure perfectly define its mass as well as light and shadow, belongs to a group of over one hundred drawings that George Knox has called *sole figure vestite* (*Tiepolo. A Bicentenary Exhibition. 1770–1970*, Fogg Art Museum, 1970, no. 71). According to Knox, these drawings can be dated after 1750, and, in general, are not related to specific figures in the master's paintings. Many of these drawings, for example, those in the Victoria and Albert Museum, are of the same size, usually larger than the present sheet; however, the *Chalchas*, in the Baltimore Museum of Art (*Tiepolo*, 1970, no. 71) has virtually the same dimensions as the present sheet. Although this figure, looking down in anger or concern, with his hands crossed on his left shoulder, cannot be connected with a particular painting, he has the overtones of an attendant figure at a *Pietà*, one of Tiepolo's most powerful themes.

74

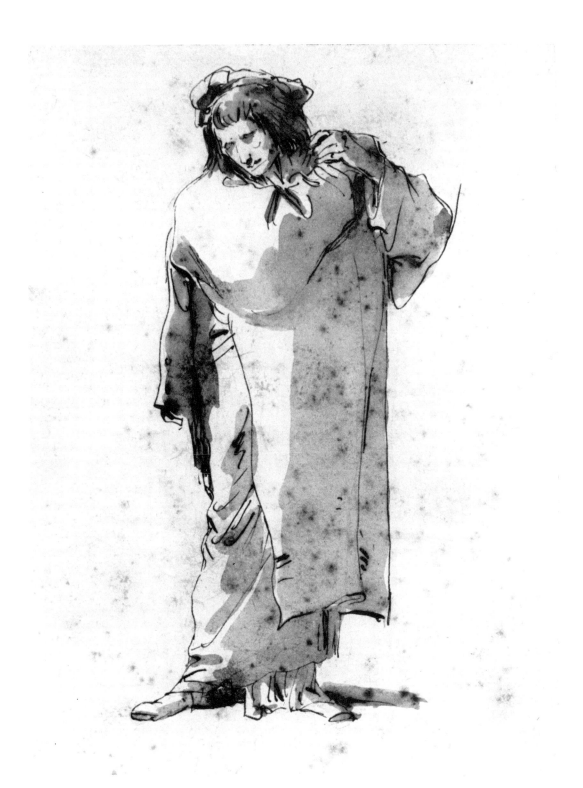

31 TWO BEGGARS

Quill pen and brown ink on antique laid paper; horizontal center fold. $13\frac{3}{8} \times 8\frac{7}{8}$ (irregular).
Blind stamp of the Ames Collection $(w+/aa)$.

PROVENANCE: Leopold Blumka, 1958.

LITERATURE: *Drawings from the Collection of Mr. and Mrs. Winslow Ames*, Providence, 1965, no. 93.

Mr. and Mrs. Winslow Ames.

This marvellously energetic drawing is typical of the work of one of the last important late baroque painters in Austria. Troger was Tyrolean and, as such, was a bridge between Italian and German art. He was in Venice from ca. 1717 to 1722, and then he traveled to Naples and to Bologna, where he was a pupil of Giuseppe Maria Crespi, like Piazzetta. He returned to Austria, and to Vienna, in 1728, where he worked for the rest of his life, producing easel paintings, altarpieces, and large frescoes that recall not only contemporary Austrian painting but also the work of Piazzetta, Sebastiano Ricci, and Giovanni Battista Pittoni that he had seen in Italy. Eckhart Knab ("Uber den Zeichenstil und einige Zeichnungen Paul Trogers," II, *Albertina-Studien*, 1, 2, 1963, pp. 80–86) has pointed out the importance of Ghezzi and Testa for his drawing style.

Troger's drawings show a distinct development from his Italian beginnings in the 1720's through his masterful, highly finished productions of the 1730's, for example, the *Marriage of the Virgin*, 1733, in the Albertina (Tietze et al., 2071 and 2072); in this decade, his work is characterized by elongated figures in dramatic poses, still clearly outlined in long, fairly straight strokes that close the figure (Monika Heffels, *Die Handzeichnungen des 18. Jahrhunderts*, Nuremberg, 1969, nos. 329–331). Although a few drawings of 1748 are in chalk (Heffels, nos. 325–327), Troger's favorite medium remains pen and ink, and by 1755, the approximate date of this drawing, his line has become much freer and looser, the strict outlines of figures have become open, or blurred by repetitions, and the clear, ordered arrangements of figures typical of his earlier compositions have been replaced by more spontaneous, less discrete compositions, as in his study for an *Adoration of the Magi* in the Albertina (no. 2087), dated there ca. 1755.

This drawing shows two beggars, an unusual subject for Troger, one a blind man, with stick and dog, the other a woman in rags, her breast exposed. They walk, perhaps to make a moral for us, among what appear to be classical, or classicizing, sculpture and architecture—behind them is the monumental base of a column and to the upper left is a right leg, set on the barest suggestion of a base. In the lower right is an unexplained left leg, executed in the nervous, restless style typical of the late Troger.

76

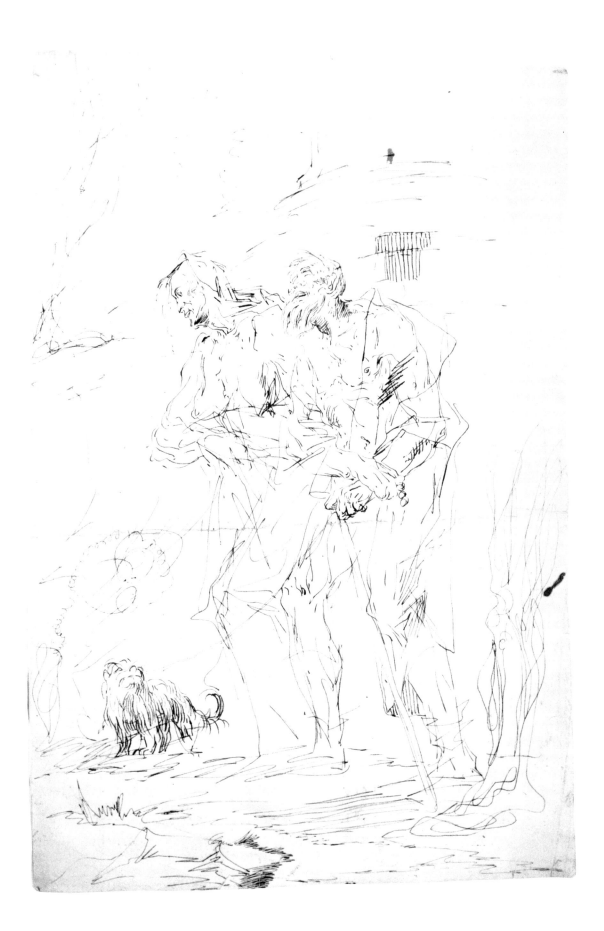

FRANÇOIS BOUCHER Paris 1703 – 1770 Paris

32 DESIGN FOR A FOUNTAIN

Black and white chalk on blue-green antique laid paper; border by another hand in pen and black ink. 14⅛ × 9. Blind stamp of the Ames Collection (*w+ /aa*).

PROVENANCE: Albert Meyer.

LITERATURE: Seymour de Ricci, *Collection Albert Meyer. Dessins du Dix-huitième Siècle*, Paris, 1935, no. 14; *Drawings from the Collection of Mr. and Mrs. Winslow Ames*, Providence, 1965, no. 11; Alexandre Ananoff, *L'Oeuvre dessiné de François Boucher*, I, Paris, 1966, no. 969 and fig. 161; *Drawings and Watercolors from Alumnae and their Families*, Vassar College, 1961, no. 59.

Mr. and Mrs. Winslow Ames.

This drawing is a typical example of Boucher's mature period, probably dating from the 1740's or 1750's. This brilliant and prolific draughtsman was always interested in the expressive rococo possibilities of water, often placing his classical gods and goddesses, or idyllic shepherds and sheperdesses, near a pool or stream, and in the 1730's he did a series of drawings of fountains, engraved by Gabriel Huquier.

The present work is looser and more summary than drawings that can be dated in the 1730's (Ananoff, nos. 247 and 248, and Regina Shoolman Slatkin, review of Ananoff, *Master Drawings*, v, 1, 1967, p. 55, and pl. 47); these works have closed outlines and clear, explicit definitions of planes and volumes. On the other hand, the Ames drawing has a vigor and sweep to the figures that is unusual in the 1760's, at the end of Boucher's life (as in Ananoff, no. 214, 1770, and the *Tête-à-Tête*, 1764, in the National Gallery of Art, Washington). Other fountain designs by the artist exist, for example, in the Cleveland Museum of Art and the City Art Museum of St. Louis.

33 LANDSCAPE WITH BUILDINGS

Black chalk, watercolor, and oil in shades of blue, rose, opaque white, brown and green on tan antique laid paper; laid down. The surface has been varnished. Watermark: illegible. 8¾ × 12.

PROVENANCE: H. J. Pfungst; Christie's, London, June 15, 1917, lot 3; Colnaghi's, London, 1929.

LITERATURE: Mary Woodall, *Gainsborough's Landscape Drawings*, London, 1939, no. 441; John Hayes, *The Drawings of Thomas Gainsborough*, New Haven and London, 1970, I, p. 191, no. 355.

Anonymous lender.

The two drawings by Thomas Gainsborough in this exhibition show an aspect of his career very different from his famous portraits of the wealthy, the elegant, and the aristocratic. Gainsborough was a student of Gravelot in London and also was deeply influenced by seventeenth century Dutch landscape painting, particularly Jacob van Ruisdael.

Gainsborough was unusual, for a successful young artist, in that he lived away from London for the greater part of his career. He lived in Ipswich from 1752 to 1759 and his drawings from that period are comparatively tight and defined. It was in his Bath period, from 1759 to 1774, that his touch becomes looser, more atmospheric, more sensitive to the shifting moods of the landscape. The present drawing, which has a pendant in the same collection, probably dates from the early 1770's, when he had given up pencil as not immediate enough to capture his effects (John Hayes, *The Drawings of Thomas Gainsborough*, New Haven and London, 1971, I, pp. 22–23). Its almost somber effect, enhanced by the massive, probably imaginary buildings and the oils and varnish, are close to various drawings executed just before his move to London (Hayes, II, fig. 120 and cat. no. 346, fig. 126 and cat. no. 352, and, especially, fig. 128 and cat. no. 363).

34 WOODED LANDSCAPE, WITH A SHEPHERD AND HIS FLOCK

Graphite, brown wash, white gouache, and black, white, and brown/orange chalks on grey antique laid paper. 9¼ × 12¼ (sight).

PROVENANCE: J. Heywood Hawkins; Arthur Kay; Christie's, London, May 23, 1930, lot 34; Mrs. Henry Goldman; Parke-Bernet, New York, February 28, 1948, lot 94.

LITERATURE: Mary Woodall, *Gainsborough's Landscape Drawings*, London, 1939, no. 8; John Hayes, *The Drawings of Thomas Gainsborough*, New Haven and London, 1970, I, p. 284, no. 765.

Mr. Eric H. L. Sexton.

This miraculous drawing, in perfect condition, shows why Gainsborough himself considered his landscapes, not his portraits, his most important work. This sheet is surely from his London period, from 1774 to the end of his life, characterized by a greater abbreviation and fluidity of movement than in the drawing preceding this one in the exhibition, from the Bath period. The landscape seems to melt across the page, transformed into light and shadow and atmosphere, hardly able to support the still airier trees that grow out of it. The work seems to be from the early 1780's, just before the great change in his style caused by his trip to the Lakes in 1783, when, as John Hayes (*The Drawings of Thomas Gainsborough*, New Haven and London, 1971, I, p. 45) puts it, "all the shapes are softened into undulating forms which pulsate across the composition and create an almost violent sense of lateral movement." Although Gainsborough has not here reached that extraordinary degree of immediacy and simplification and energy that characterize the drawings of the last three or four years of his life, the control of the wash as it flows over the contours of the landscape, the rhythms of the tree trunks that sway from side to side back into space, and the scattered touches of white chalk create a work that is as rococo as a drawing by Boucher and yet is peculiarly English. The shepherd with his flock, although not emphasized here, reminds us that he was not indifferent to subject matter, and particularly woodmen, shepherds, and other members of the rural poor, sometimes reminiscent of Murillo.

GIOVANNI DOMENICO TIEPOLO *Venice 1727 – 1804 Venice*

35 A MAN AND A HORSEMAN, SEEN FROM THE BACK

Brown ink with quill pen, brown wash over traces of black chalk on cream antique laid paper. There is a pencil outline along the upper edge. Watermark: four-legged walking bird. There is a long vertical crease through the left half of the drawing which was present in the sheet of paper before the drawing's execution. Adhesive stains at the four corners are identical in type to those on the drawing by the same artist of Hercules and Antaeus, no. 37, as is the red chalk numeral; thus, these two drawings may be presumed to have a common provenance. 7¼ × 9⅝.
Signed in pen and brown ink at the lower right, *Dom Tiepolo f.*; verso, in red chalk, *53*.

PROVENANCE: Apolloni, Rome.

Professor and Mrs. Melvin J. Zabarsky.

Giovanni Domenico Tiepolo was the son and pupil of Giovanni Battista Tiepolo, and his early work, as in the present drawing, was much under his influence. However, as can be seen from the four drawings from Domenico's hand in this exhibition, the son transformed the rococo splendor and virtuoso power of his father into a style of his own, characterized by a greater colloquial and anecdotal quality, a wonderful responsiveness to the various aspects of everyday life, often humorous and even satirical.

This drawing is almost certainly the earliest of the four and is closest to his father's drawings; for example, a drawing by Giovanni Battista in Stuttgart (George Knox, *Tiepolo*, Stuttgart, 1971, no. 12) shows two figures from the back in a similarly loose and summary style and can be dated ca. 1745. Another drawing of various figures, this time by Domenico, and dated by J. Byam Shaw ca. 1755–1760 (*The Drawings of Domenico Tiepolo*, Boston, 1962, p. 75, no. 14), is close to this drawing in its loose outlines of parts of the body, filled in with flat areas of wash. Giovanni Battista occasionally uses horsemen seen from the back, most dramatically in his two early paintings in the Metropolitan Museum, the *Conquest of Carthage* and the *Battle of Vercelli*. Domenico himself often uses a similar group, placed to the side of the painting, to lead the viewer into the composition, as in his frescoes in the church of Sts. Faustino and Giovita, in Brescia, a scene with a group of gypsies, in the Gemäldegalerie, Mainz, and, most dramatically, in his various versions of the story of the Trojan Horse (Adriano Mariuz, *Giandomenico Tiepolo*, Venice, n.d., nos. 75, 76, 82, and 268–271).

36 SEVEN OWLS

Pen and dark brown ink, grey wash, traces of a brown wash, with black chalk, on antique laid paper. Watermark: *P P*. 10½ × 7¾.

Signed in pen and brown ink, *Dom Tiepolo f*; blind stamp of the Ames Collection (*w*+ /*aa*).

PROVENANCE: Hermitage, Leningrad (discharge stamp on verso); Hermitage drawing sale, C. G. Boerner, Leipzig, 1931, part of lot 244; Dan Fellows Platt; Ferargil Gallery, 1939.

LITERATURE: J. Byam Shaw, *The Drawings of Domenico Tiepolo*, Boston, 1962, no. 46; *Drawings from the Collection of Mr. and Mrs. Winslow Ames*, Providence, 1965, no. 90; Aldo Rizzi, *Le Acqueforti dei Tiepolo*, Udine, 1970, fig. III; Aldo Rizzi, *The Etchings of the Tiepolos*, London, 1971, fig. V; *Drawings and Watercolors from Alumnae and their Families*, Vassar College, 1961, no. 70.

Mr. and Mrs. Winslow Ames.

This vivid and charming drawing is based on Giovanni Battista Tiepolo's etching, the frontispiece to his suite of etchings, the *Scherzi*, probably executed in the late 1730's or early 1740's. Domenico's relationship with this group of prints was intimate; not only did he make this variant of the frontispiece, but he reissued the whole set in an edition after his father's death, with an inscription added to the frontispiece. In addition, as Rizzi has pointed out (1971, p. 34), the frontispiece to his first set of etchings, the *Stations of the Cross* of 1748, has a similar composition, if not subject, to the father's brooding, ominous print of these owls settling on a large marble slab. Domenico has made several changes in transferring his father's print to this sheet: the slab has become a mound of earth, the scowling owl in the foreground has been placed to the right, and a long branch leading from the lower right into the background has been omitted. These changes help transform the work into something typical of Domenico; the son's more open, relaxed, colloquial atmosphere is more apparent, with more empty space at the top of the sheet. The owls become less menacing, the foreground owl's prey, dead at his feet, has been removed, and the whole composition has been placed on a parapet or ledge, removing it from us.

This ledge leads Byam Shaw (1962, pp. 42, 81) to include it in a series of animal drawings with similar ledges that can be connected with Domenico's remaining frescoes in the Villa Tiepolo-Duodo at Zianigo, ca. 1793. A drawing remarkably similar in style, the *Monkey and Monkey Skeletons*, in the collection of Dr. and Mrs. Rudolf Heinemann, New York, is also indebted to his father's work and may indicate that both these drawings, although probably neither is from the 1750's, still should be placed early in this animal series.

Owls are important in the work of both Tiepolo's, and appear again and again in Giovanni Battista's *Scherzi*. Although this bird has conveyed many meanings in the history of art, surely here, often perched on a dead branch, it has the overtones of the owl as inhabitant of ruins and reminder of death and the presence of sin (Heinrich Schwarz and Volker Plagemann, "Eule," *Reallexikon zür deutschen Kunstgeschichte*, Stuttgart, 1970, columns 267–322). Domenico may have been aware of such implications, since his addition, in the Heinemann drawing, of a chain and two monkey skeletons to his father's conception clearly adds a moralizing meaning to the subject. The chained monkey appears again, in reverse, in a drawing by Domenico in the Musée des Arts Décoratifs, Lyon.

37 HERCULES AND ANTAEUS

Black ink with quill pen and grey wash with touches of black chalk, on antique laid paper, with a brown ink border at all edges; lightly foxed. Adhesive stains at the four corners are identical in type to those on the drawing of the same artist of two horsemen, no. 35, as is the red chalk numeral; thus, these two drawings may be presumed of have a common provenance. 9¾ × 7⅝.
Signed in pen and black ink, *Dom . . . Tiepolo f.*; verso, in red chalk, *55*.
PROVENANCE: Apolloni, Rome.

Dr. and Mrs. Maurice Shulman, on loan to the University Gallery, University of New Hampshire.

Hercules and Antaeus was a favorite subject with Domenico, and Byam Shaw (1962, p. 38) notes an album of some thirty-eight drawings of the subject which can be connected with the Zianigo frescoes, ca. 1793. As George Knox has pointed out (letter, February 14, 1973), this drawing is different from most of the others in that it shows a fully developed landscape; in addition, it is slightly larger and has grey wash rather than brown, and lacks the ledge or parapet at the bottom typical of many of the other *Hercules and Antaeus* subjects and of the Zianigo frescoes. The drawing is typical of Domenico's charming ability to populate a familiar Italian landscape, complete with rustic buildings in the background, with figures drawn from classical mythology.

GIOVANNI DOMENICO TIEPOLO *Venice 1727 – 1804 Venice*

38 INTERIOR WITH CARD PLAYERS, A PRIEST AND OTHER FIGURES

Brown ink with reed pen and brown washes over graphite on white antique laid paper; laid down. 11⅜ × 16¼.
Signed in pen and brown ink, *Dom-Tiepolo |f| 1791*. Recto of mount, in graphite, *≢30/49*.
PROVENANCE: Alfred Beurdeley; sale, Paris, Rahir, May 3, 1920; sale, London, Sotheby's, July 6, 1967, lot 50; Colnaghi's, London, 1967.
LITERATURE: George Knox, *Tiepolo*, Fogg Art Museum, Cambridge, 1970, no. 103.
Mr. and Mrs. Paul Bernat.

One of the most appealing aspects of Domenico's drawings is a large series of works from the 1790's showing various levels of eighteenth century Venetian society. The subjects range from dancing bears to street shows to fashionable ladies and gentlemen out walking or gracefully greeting each other or, as here, playing cards together. Most of them, like this drawing, have overtones of mild caricature, but Domenico, in his sixties after a successful career, is more affectionate and humorous in his attitude than biting.

ANTON RAPHAEL MENGS *Aussig (Bohemia) 1728 – 1779 Rome*

39 STUDY OF LEGS

Red chalk over graphite on cream antique laid paper; some slight glue stains around old mends and laid down on an old mount. There is a pencil border at the side and lower edges. There is a heavy horizontal line drawn on the verso through the points of contact of the feet with the assumed ground. This was undoubtedly easily visible through the sheet before it was mounted; it should be considered a technical aid in positioning the striding legs firmly on the horizontal plane. Watermark: Strasburg bend. 11⅝ × 9¾.

Anonymous lender.

This tense, yet frozen drawing, powerfully muscular but flattened out by the background shading and the placing of the feet on the same plane, is by perhaps the most prominent of the early neo-classical painters. Born in Bohemia, Mengs established himself in Rome by 1746, before he was twenty, became friends with the great art historian and classicist, Winckelmann, and studied in Rome not only the art of the Italian Renaissance, particularly Raphael, Michelangelo, and Correggio, but also the newly discovered frescoes at Pompeii and Herculaneum. Throughout most of the 1760's he worked as court painter in Madrid, at the same time as the greatest representative of the preceding generation, Giovanni Battista Tiepolo. In 1769 he returned to Rome, where he executed the painting, an *Adoration of Shepherds*, 1771–1772, now in the Prado (Dieter Honisch, *Anton Raphael Mengs und die Bildform des Frühklassizismus*, Recklinghausen, 1965, p. 105, no. 152), for which this drawing is the preliminary study.

The legs are those of a shepherd striding toward the Christ child from the right foreground and carry much of the tension and action of the whole painting, which is deeply indebted to Correggio; the same contrast of one foot flat on the ground and the other pushing against it is used as a focal point for a whole composition in another painting, a *Flagellation*, in the Palacio Real, Madrid, ca. 1765–1768 (Honisch, p. 99, no. 124). Throughout his career, Mengs's figure drawings were often characterized by carefully modelled forms and subtle modulations of skin tone, as in his *Salmacis and Hermaphrodite*, Museum Boymans-van Beuningen, Rotterdam, or his study of a nude man in the Albertina (Hans Tietze et al., no. 1906), but another drawing in the Albertina (no. 1918), showing God the Father, and datable to 1773, is particularly close to this work in its controlled strength and hard, flat forms.

JEAN-HONORÉ FRAGONARD Grasse 1732 – 1806 Paris

40 THE BRIGANDS DISCOVER ORLANDO WITH ISABELLA AND GABRINA

Black chalk and brown and grey washes on cream antique laid paper; black chalk border at the upper edge. Watermark: *BM.* 15½ × 9¾.

PROVENANCE: Hippolyte Walferdin; Jacques Doucet; Louis Roederer; The Rosenbach Company, 1928.

LITERATURE: Elizabeth Mongan, Philip Hofer, and Jean Seznec, *Fragonard Drawings for Ariosto*, New York, 1945, pl. 94; Royal Academy of Art, London, 1968, fig. 296.

Anonymous lender. *J. N. Brown*

This vivid, powerful drawing, infused with the energy of the draughtsmanship of Rubens and Tiepolo, is one of 137 sheets that Fragonard executed to illustrate the great epic poem of the sixteenth century, Ariosto's *Orlando Furioso*; the artist made still more drawings connected with this text, but outside this series (Elizabeth Mongan, *Fragonard Drawings for Ariosto*, pp. 21–22). Fragonard also illustrated the *Contes* of La Fontaine and *Don Quixote*, but only those for La Fontaine were finally published.

These drawings, probably from the 1780's (Mongan, p. 22), are the perfect visual translations of Ariosto's dramatic, enormously popular and influential series of amorous and military adventures and battles.

Fragonard spent several years in Italy and must have known the Italian language fluently; certainly the present drawing, illustrating an incident from Canto xiii, 32–33, follows the original text closely, with the brigand one-eyed and armed to the teeth, gesturing to the little group as he leads the rest of his gang into their cave. As so often in this series, Fragonard has chosen the most dramatic, even theatrical moment in the incident, capturing the "merciless visage" of the first brigand, the air of fearful expectancy in the figures in the background, and the rush of figures in the upper left down the steps to their hideout.

41 MUSE, OR SAPPHO

Pen and brown ink, brown wash, graphite, on thick paper. The sheet has been cut down; traces of a *t* and another letter, in pen and brown ink, can be seen at the top edge of the sheet (legible only when the drawing is turned so that the present left edge is at the bottom). Left edge, a stain caused by a former hinge (or piece of tape). Top edge, on left, a vertical tear repaired. Verso, traces of a previous paper mount still adhere to the sheet. 11⅞ × 9¹⁵⁄₁₆ (slightly irregular). Mark of the Laporte collection (Lugt 1170); verso, mark of the Held collection (H, J, and S in monogram, in black ink).

PROVENANCE: G. L. Laporte.

LITERATURE: *Selections from the Drawing Collection of Mr. and Mrs. Julius S. Held*, Binghamton, 1970, no. 12.

Professor and Mrs. Julius S. Held.

Although Romney is perhaps best known for his paintings, and particularly his elegant variations of the eighteenth century English aristocratic portrait, derived in large part from Anthony van Dyck, his drawings and oil sketches have a remarkable power and wild imaginativeness that look forward to the artists around Blake and Fuseli. The present sheet, a classical subject but with the suggestion of a portrait, is an example of a common tradition in eighteenth-century England and France, presenting a young lady or a matron as a classical goddess or other such personage, as in Romney's own *Miss Vernon as Hebe*, in the collection of the Earl of Warwick.

The Held drawing has a sweep and simplicity, contained, as usual, inside a border within the sheet, that are close to other of his best drawings, such as the first study for the *Infant Shakespeare Nursed by Comedy and Tragedy*, and the *Mother and Child*, both in the Fitzwilliam Museum, the *Mother Reading to a Child*, in the collection of Lord Ronald Sutherland Gower, or the *Letter Writer*, in the Metropolitan Museum (reproduced, Lord Ronald Sutherland Gower, *George Romney*, London, 1904, n.p.). The present drawing is similar in style to a sketch for a portrait of a lady, in the collection of Mr. and Mrs. J. Richardson Dilworth, Jr., and other sheets, which Patricia Milne-Henderson (*The Drawings of George Romney*, Smith College, 1962, nos. 60 and 44) dates in the mid-1780's.

BENJAMIN WEST Springfield, Pennsylvania 1738 – 1820 London

42 THE ADORATION OF THE SHEPHERDS

Quill pen and dark brown ink, brown and other colored washes, graphite, blue chalk, extensively heightened with white and other colored pigments. The artist has added extensive borders in grey ink and grey wash, with a strip of gilt paper laid down. On a thick rag paper. Watermark: fleur-de-lys, within a shield, surmounted by a crown, the whole about 7 inches long. Traces of a previous, brown paper mount on the verso. Image, $9\frac{1}{16}$ × $12\frac{7}{8}$; sheet, $13\frac{3}{4}$ × $17\frac{9}{16}$.
Inscribed within the image, in pen and dark brown ink, *B. West 1805* (or *1801*) (the date underlined); inscribed in the bottom right corner of the sheet, in pen and brown ink, in an old hand (probably not the artist's), *No 9* (or *7*). Verso, mark of the Held collection (H, J, and S in monogram, in black ink).
PROVENANCE: Central Picture Galleries, New York; Mrs. Jacob M. Kaplan.

Professor and Mrs. Julius S. Held.

This highly worked drawing, complete with a border by the artist himself (a practice that became common in the eighteenth century), shows the draughtsmanship of this American expatriate living in London at its best. The handling of light here, and particularly the device of Joseph's hand hiding the lamp, is typical of seventeenth-century models, particularly of the Caravaggesque tradition; in fact, the late eighteenth century is the time of a resurgence of interest in Guercino's pen and ink drawings, in the drawings and prints of Pietro Giacomo Palmieri, Pietro Antonio Novelli, Adam Bartsch, and Francesco Bartolozzi, the reproductive engraver who worked in London. Another seventeenth century source for West seems to have been the paintings of Salvator Rosa.

The present drawing, which the collector has informed us is from a series, comes at the end of what Grose Evans (*Benjamin West and the Taste of his Times*, Carbondale, 1959, pp. 55–82) has called his Dread Manner (1783–1805), in which the neo-classicism of his first period, the Stately Mode, has been infused with an emotional intensity similar to that of contemporary artists in England, such as William Blake, Henry Fuseli, or, in his drawings, George Romney.

FRANCISCO JOSÉ DE GOYA Y LUCIENTES
Fuendetodos 1746 – 1828 Bordeaux

43 TWO PEASANTS FIGHTING WITH EACH OTHER

Brown and very dark brown wash on off-white Spanish Paular paper, laid lines horizontal, 24, 25 mm. Mounted on pink paper used by the artist's son Xavier Goya. 8⅛ × 5¹¹⁄₁₆.
Inscribed at the top of the sheet, in graphite (?), *73*.

PROVENANCE : Clementi collection, Rome.

LITERATURE : Valerio Mariani, "Primo centenario della morte di Francesco Goya—disegni inediti," *L'Arte*, XXXI, 1928, pp. 97–108, fig. 5; Tomas Harris, 1971, no. 1492.

Anonymous lender. *E. Sayre*

Goya valued the opinions of the members of the Academia de San Fernando and took pains that they should see those works of which he was proud. They in return had themselves portrayed by him, rightly perceiving that his genius for the swift portrayal of male or female vitality, of mind, of personality, outweighed any carelessness in execution.

His paintings they knew, but probably few of his colleagues were permitted to see his drawings. They fall almost entirely into two groups: studies for series of prints, and the contents of eight Journal-Albums. He never dared publish either the *Desastres* treating the Peninsular War and its terrible aftermath, or the *Disparates* with their veiled criticisms of Church and State. The Journal-Albums contained entries of varying lengths on what Goya thought, sometimes with humor, often seriously, about a great range of subjects.

These books were the pictorial equivalent of the manuscripts Spanish writers, such as his friends Moratin and Gallardo, passed from hand to trusted hand because they could not be published in a country where both the State and the Inquisition exercised censorship.

In this sheet, page 73 of Journal-Album F, one scarcely notices the anatomical inconsistencies so cogent is Goya's representation of the bitter rage with which the two peasants struggle to kill one another. In page 74 in Rotterdam, two women are engaged in a less deadly fight.

The drawings from this book are in brush and brown wash, occasionally heightened with white or touched with grey. It had been begun by 1819 since page 12, one of six drawings of duellers, was used as the basis for a lithograph printed that year in Madrid.

ELEANOR A. SAYRE

44 THE OVERDROVE OX

Black ink and watercolor in shades of grey, blue, and rose over traces of graphite on cream antique laid paper; the sheet is mounted on an early decorated mount with a border of fine black lines, the innermost on the drawing sheet itself. 13⅜ × 19⅜.

Anonymous lender.

This marvelous composition is a typical example of the early work of one of the greatest masters in the English genre and caricature tradition. At fifteen, Rowlandson was already enrolled in the drawing class at the Royal Academy, and drawings remained his most characteristic medium throughout his career. Although the basic influences on his style were English, particularly Hogarth and Mortimer, trips to the Continent also made him responsive to Fragonard and the seventeenth-century Dutch.

Rowlandson caricatured a wide variety of subjects, from the wealthy taking the waters at Bath to gamblers and lovers to politicians and public personalities, and he particularly loved to show animals running wild, upsetting the manners and pretensions of the poor and the rich, the young and the old. In this drawing, there is no suggestion of the grisly, savage overtones of such a series from near the end of his life as the *English Dance of Death*, 1814–1816, executed in a powerfully abbreviated shorthand. The runaway bull is simply an excuse to show the comical confusion of the man with a parasol and his servant carrying his wig, the baldheaded man falling over a milkmaid and leering at her, the fleeing beggar on crutches, a violin hanging from his neck, the youth carrying a coffin on his back, and the capsizing coach. As he often does (Ronald Paulson, *Rowlandson. A New Interpretation*, New York, 1972, p. 29), the artist contrasts the disorder of the people with the regularity, indeed, serenity, of the architecture that rises around and above them. The erotic symbolism of the milkmaid is stressed in a later drawing of a student kissing a girl, one of whose pails is stuffed with two children, while a dog laps milk from the other and an enraged don looks on (Victoria and Albert Museum).

The middle and late 1780's were the period of Rowlandson's largest and most dynamic, highly worked compositions, such as his *Skating on the Serpentine*, 1784, in the London Museum, the *English Review* and the *French Review*, 1786, at Windsor Castle, and the *Prize Fight*, 1787, in the Paul Mellon Collection; and this is probably the date of this drawing. Although large scenes of fairs or public squares, packed with people, appear later in his career, particularly ca. 1800, these drawings are usually more static, with the figures evenly distributed across the sheet, instead of packed in bunches on either side, as in this work.

45 OBERON AND TITANIA

Watercolor in shades of green, grey, rose, yellow, and blue on cream antique laid paper. Watermark: fleur-de-lys in cartouche with pendant script W (fragment). (Churchill 415, Whatman 1782. Churchill lists this watermark in the Strasburg lily section, p. 84, but draws it on p. cccx with the cartouche containing a posthorn.) $8\frac{5}{16} \times 6\frac{7}{16}$.
Verso, in graphite, *William Blake | Oberon + | Titania.*

Anonymous lender.

This drawing is a particularly important example of Blake's draughtsmanship; it is, first of all, typical of his style of the 1790's and throughout his career, the neoclassicism of the late eighteenth century transformed into images that are imaginative, mystical, possessed, otherworldly. Also, this drawing of figures among flowers, one of Blake's favorite themes, was used as a preparatory study for the fifth plate of his short book, *The Song of Los*, 1795, printed at Lambeth. Most of Blake's great books come from the 1790's— *Songs of Innocence and Experience*, *The First Book of Urizen*, *The Marriage of Heaven and Hell*, *Visions of the Daughters of Albion*, and *Night Thoughts*; *There Is No Natural Religion* and *The Book of Thel* were made in the late 1780's, and his illustrations to the *Book of Job* and to Dante are from the 1820's.

Although the *Song of Los* is not Blake's greatest book, it adumbrates many of the themes that were to occupy his writing in later years; the book, which consists of eight plates, is comprised of two poems, "Africa" and "Asia," and was sometimes bound together with two other of his books, *America*, 1793, and *Europe*, 1794. Text and images of the *Song of Los* are powerful, pessimistic, apocalytic: contorted figures, figures upside down, a couple running away, an old man praying, another with his hand on a skull, a young man with a hammer above a globe, and a text that conveys the threat of some

imminent, overwhelming change, a Second Coming, a "Call from Fires in the City/For heaps of smoking ruins." Although this plate is usually fifth, in at least one copy (G. E. Bentley, Jr., *The Blake Collection of Mrs. Landon K. Thorne*, New York, 1971, no. 10 and pl. xix) it is the final sheet in the book, a sublimely simple ending to a short but concentrated volume.

The present drawing is important for other reasons as well. G. E. Bentley, Jr., has pointed out (letter to the collector, October 8, 1969) that this is the only occasion where Blake made a print (in reverse) so precisely similar to one of his drawings, except for the studies for Dante and *Job*, and even these are not so close as in this case. Perhaps this circumstance is related to the fact that the drawing is, in turn, based on another drawing, by his younger brother Robert, of similar but unidentified composition, with several more figures dancing among the flowers (Geoffrey Keynes, *Blake Studies*, second edition, Oxford, 1971, pl. 3). Blake's devotion to Robert, who died in 1787 at age nineteen, is well-documented, and Robert's drawing has come down to us in his elder brother's *Notebook*, formerly known as *The Rossetti Ms*. Perhaps the care with which this composition was transferred from one drawing to another to the printed book was partly a result of Blake's love for his brother and a desire to perpetuate or acknowledge one of his compositions.

PIERRE PAUL PRUD'HON Cluny 1758 – 1823 Paris

46 WOMAN AND SLEEPING CHILD

Black and white chalk; laid down on an old mount, in a nineteenth-century mat. $2^1/_8 \times 5^1/_2$.
Verso of the old mount, mark of the Held collection (H, J, and S in monogram, in black ink). Verso of the nineteenth-century mat, in graphite, *Innocence*.
PROVENANCE: Sotheby's, London, late 1960's.

Professor and Mrs. Julius S. Held.

Prud'hon is one of the most individual personalities of late eighteenth century French art. Although, like David, he supported the Revolution and became one of the favored painters of Napoleon's government, he is clearly different from David and Girodet and, as has often been noted, looks forward to nineteenth-century Romanticism. His powerful drawings, especially those of nude women in black and white chalk on blue paper, show a neoclassical solidity of pose and volume, combined with a sensuous *sfumato* reminiscent of Leonardo and, even more, Correggio. Although the present drawing is tiny, it loses none of the master's monumentality and, simultaneously, modest sensuality. The sub-ject of a mother and child is not uncommon in Prud'hon's work; Jean Guiffrey (*P. P. Prud'hon. Musée du Louvre. Peintures, Pastels et Dessins*, Paris, 1924, p. 41, no. 32) dates a larger drawing in black and white chalks, in the Louvre, to 1810. More importantly, the present drawing is clearly related to a painting by Constance Mayer-Lamartinière, exhibited in the Salon of 1810 and now in the Louvre, for which Prud'hon did at least ten preparatory studies (Jean Guiffrey, *L'Oeuvre de Pierre-Paul Prud'hon*, Paris, 1927, nos. 730–739). The painting, called *The Happy Mother*, in a vertical format, is a companion piece to her *Unhappy Mother*, also in the Louvre.

JOHN VANDERLYN *Kingston, New York 1775 – 1852 Kingston*

47 STUDY FOR THE FIGURE OF MARTIN ALONZO PINZON, IN *THE LANDING OF COLUMBUS*

Black and white chalk, grey wash, on blue paper; laid down. 16 × 13⁵⁄₁₆.

LITERATURE: *150 Years of American Drawing 1780–1930 from the Collection of John Davis Hatch*, Williamstown, Mass., 1965, no. 4; *American Drawings, Pastels, and Watercolors*, I, The Kennedy Galleries, New York, 1967, no. 130.

John Davis Hatch Collection of Drawings by American Artists.

This drawing is a preparatory study for the figure of Martin Alonzo Pinzon in one of the most famous American paintings of the nineteenth century, *The Landing of Columbus on San Salvador, October 12, 1492*, 1839–1846, in the Rotunda of the Capitol, Washington. Although the painting proved to be, in the end, a long and disappointing venture for Vanderlyn, it was the major achievement of this artist, who was essentially a portraitist, and served as the basis for designs of currency and postage stamps later in the century.

Over thirty drawings for the *Landing of Columbus* have been published, and this group especially reveals Vanderlyn's sensitivity to the play of light and shadow and to details and textures of drapery, within the context of the idealized gestures and poses of history painting of this nature, undoubtedly influenced by the works he saw in Paris and Rome as a young man. This particular figure, just to the left of Columbus himself, was the subject of several studies (*American Drawings, Pastels, and Watercolors*, I, Kennedy Galleries, New York, 1967, nos. 131, 132); each of these drawings presents the figure differently, against a dark background, as a series of volumes, or as a study of light falling across a cape. The distance between Vanderlyn's own drawings for the painting and those by his assistant may be seen by comparing the present work with a costume study by his (French?) assistant, Senate House Museum, Kingston (Kenneth C. Lindsay, *The Works of John Vanderlyn*, Binghamton, New York, 1970, no. 70, pp. 91 and 143).

48 DR. JOHN WARREN

Black, white, and light brown chalks, stumping, graphite, on dark brown paper; laid down. The two upper corners have been cut and laid down again. The original color of the paper, still visible along the left and lower edges, was light brown. 14⅛ × 11.

PROVENANCE: *Victor Spark, ca. 1960.*

LITERATURE: *150 Years of American Drawing 1780–1930 from the Collection of John Davis Hatch*, Williamstown, Mass., 1965, no. 6 (illustrated).

John Davis Hatch Collection of Drawings by American Artists.

Rembrandt Peale was one of a large family of artists, of whom the best-known are his father, Charles Willson Peale, and his brother, Raphaelle. Rembrandt travelled to Europe several times and studied with Benjamin West; unlike Raphaelle, he was successful throughout a long career, making portraits of many distinguished nineteenth-century Americans and some Europeans.

Although some falling off in quality may be observed in his later works, traceable, for example, in his self-portraits, his drawings remain vigorous and incisive; his portrait drawing of John C. Calhoun of 1838 in the collection of Charles Coleman Sellers, for instance, has an inner strength lacking in the finished painting, in the Gibbs Art Gallery, Charleston (Charles H. Elam, *The Peale Family*, Detroit, 1967, pp. 106–107). The present drawing is a preparatory study for a portrait of Dr. John Warren, of which there are, evidently, several replicas; Laura M. Huntsinger (*Harvard Portraits*, Cambridge, 1936, p. 142) describes Harvard's version as a copy by Leslie P. Thompson. If the portrait is of the elder John Warren (as identified by Huntsinger), then we could establish the drawing as having been done before 1815, the date of Warren's death. However, Peale would have received such a commission only after his first sojourn in London, in 1801, or even later, after returning from his trip to France and Italy in 1809, when Warren would already have been in his late fifties (he was born in 1753). Certainly, judging the age of a sitter is always problematical, but it is difficult to see this face as that of a man close to sixty. There is a possibility that the sitter may be his son, Dr. John Collins Warren, who was born in the same year as Peale himself. In any case, both Warrens were distinguished surgeons and professors at the Harvard Medical School.

EUGÈNE DELACROIX *Charenton–Saint-Maurice 1798 – 1863 Paris*

49 HAMLET AND THE GRAVEDIGGERS

Black chalk and touches of graphite on laid paper. Watermark: *E* and *R*, in monogram, within a heart-shaped shield, surrounded by a wreath, and surmounted by a smaller wreath. 11⅜ × 7⅞.
Atelier stamp in red, *E.D.*

PROVENANCE: Atelier sale of the artist; Eugène Lecomte, sale, Paris, June 11–13, 1906 (?); Kraushaar Gallery, 1936.

LITERATURE: *Drawings from the Collection of Mr. and Mrs. Winslow Ames*, Providence, 1965, no. 19.

Mr. and Mrs. Winslow Ames.

Shakespeare, along with Goethe, was one of the most popular literary sources for nineteenth century Romantic imagery and was a particular favorite of Delacroix, who could read him in the original English. The present drawing, with Yorick's skull, is a preparatory study for the lithograph of 1843, from the series of sixteen illustrating *Hamlet*. Delacroix had already treated the same moment in the play twice before, in a lithograph in 1828 (and a preparatory drawing for it in the Albertina) and a very similar painting of 1839, in the Louvre; in 1859, he returned to the theme, adding a wider view of the cemetery (Robaut, no. 1388). Another study for the 1843 lithograph is in the Musée Bonnat, Bayonne. The collector has pointed out that Delacroix made a tracing of this drawing in 1855 and dedicated it to Liszt; the tracing, of almost precisely the same dimensions as this drawing, was in the collection of Princess Carolyne Sayre-Wittgenstein (sale, Hirsch, Munich, November 26, 1921, no. 52).

50 TWO LADIES IN A CARRIAGE. Verso, in graphite: slight sketch of a woman's head and torso seen from the back.

Pen and brown ink and grey wash on tan wove paper. 7⅞ × 12.
Anonymous lender.

Guys was an extraordinary personality; born in the Netherlands where his father was part of the French force of occupation, he remained a traveller throughout most of his life and recorded, in a remarkable number of drawings, a wide variety of countries and social classes, both elegant and squalid. He was so reticent about publicizing his own life or work, it is difficult to be sure of the truth of stories that place him with Byron at Missolonghi or that suggest he was one of the first artists to work for *The Illustrated London News* and *Punch*. It is sure that he was in London, as a teacher of French, 1842–1848, and that he was making many drawings then.

Guys was a friend of Daumier, Delacroix, the Goncourts, and Nadar, who took many photographs of him; Thackeray wrote an essay on him and Manet did one of his most powerful portraits of him. Most particularly, Baudelaire wrote one of his most impassioned and eloquent essays, or rather series of short essays, on Guys, "Le Peintre de la Vie Moderne," in which Guys, characteristically, insisted on remaining anonymous. Baudelaire was impressed with the artist's responsiveness to the world around him, not just the refined dandyism for which he is now famous, but also the world of prostitutes, rendered frankly and unsentimentally; even in this drawing,

the stiff, sphinx-eyed ladies are presented with a touch of cynicism that exists side by side with his delight in the elegant carriage, flowing dresses, and graceful horse. For Baudelaire, Guys captured "the transient, fleeting beauty of actual life, . . . the character of . . . *modernity*" (P. G. Konody, *The Painter of Victorian Life*, London, 1930, p. 172).

These quick, spontaneous sketches, often on cheap paper, are rarely signed or dated, and return again and again to the same subjects—Baudelaire, for example, devoted a whole chapter just to Guys' carriages. However, the present drawing is clearly after his London sojourn of the 1840's and may date from the 1860's (see, for example, Bruno Streiff, *Constantin Guys 1802–1892*, London, 1956, no. 69, dated 1853; François Boucher, *Au Temps de Baudelaire, Guys et Nadar*, Paris, 1945, pp. 96–97, dated 1865; and Georges Grappe, *Constantin Guys*, n.d., p. 47, dated 1855). The drawing seems to accord well with the looser, more open style of the 1850's and 1860's suggested by Luce Jamar-Rolin ("La Vie de Guys et la Chronologie de son Oeuvre," *Gazette des Beaux-Arts*, July–August, 1956, pp. 69–112), although here the evolution of costume style does not give the help in dating it often does.

HONORÉ DAUMIER *Marseille 1808 – 1879 Valmondois*

51 FIGURE OF A MAN

Quill pen and black and grey ink, grey wash, on laid paper; graphite line along left edge and other touches of graphite and of pen and brown ink in lower left. 3⅝ × 3⅛.
Signed in pen and brown ink, *h D.*

PROVENANCE: Max Liebermann; César de Hauke; sale, Gutekunst and Klipstein, 1948, no. 43; Dr. Bruck, Buenos Aires.

LITERATURE: *Ausstellung Honoré Daumier 1808–1879*, Galerie Matthiesen, Berlin, 1926, no. 137 (lent by Max Liebermann); K. E. Maison, *Honoré Daumier. Catalog raisonné of the Paintings, Watercolors, and Drawings*, II, Greenwich, Conn., 1968, no. 445, pl. 152. (The short, straight lines perpendicular to the bottom center edge and right center edge are not in Maison's reproduction.)

Anonymous lender.

This masterpiece of concentration and energy shows Daumier's draughtsmanship at its best; it is not surprising to learn that it was once owned by the distinguished German Impressionist Max Liebermann, who was known almost as much for his cynical wit as for his paintings and drawings. Daumier's pen drawings are almost impossible to date (Maison, II, pp. 8–9), since the artist could pick up or put down his styles as easily as he could turn from the realm of politics and the courts to scenes from domestic life and the world of actors, clowns, and audiences. Like Guys, he was "a painter of modern life" and was even more deeply involved in the specific issues and events of his time, as well as contemporary manners and morals.

The present drawing most probably represents a character from one of Molière's plays, perhaps *Le Malade Imaginaire*, a subject he treated more than once (Maison, II, nos. 475, 476, 485, 486). Daumier made many drawings of this small size, exploring various expressions and physiognomies.

ADOLF MENZEL Breslau 1815 – 1905 Berlin

52 FOUR STUDIES OF A WOMAN'S HEAD

Graphite, with stumping; laid down. 7¼ × 4¹¹⁄₁₆.
Signed in graphite, *A. M | 92.*
PROVENANCE: H. Shickman, New York, 1965 (no. 73).

Anonymous lender.

Adolf Menzel, who lived to the age of ninety, was an extremely prolific painter, draughtsman, printmaker, and illustrator. He was running a professional lithography business at sixteen, after his father's death, and a remarkable variety of subjects—scenes from the theater, eighteenth century costume dramas, Italian piazzas, buildings, factories, landscapes, portraits, religious scenes, domestic anecdotes—poured out of him throughout the rest of his highly successful career.

Today, it is his drawings that, perhaps, seem most powerful, and particularly his drawings of the 1880's and 1890's; the best of these works are of single figures, on long and narrow sheets of paper, in black chalk, and are free of anecdote or any illustrative overtones. There is much stumping and smudging and, above all, multiple views of the same figure; although several of his finest drawings are from 1892 (H. W. Singer, *The Drawings of Adloph von Menzel*, New York and London, n.d., plates XXXIV, XXXVII), the level of quality throughout the last two decades of his life, when he was in his seventies and eighties, is remarkably high. Even in 1904, the year before his death, he could still create characters that are simple, monumental, and intense (Singer, pl. XLVII). The naturalism of these last years is, to some degree, paralleled by similar concerns in the work of the younger German artist, Wilhelm Leibl.

MARTIN JOHNSON HEADE Lumberville, Pennsylvania 1819 –
1904 St. Augustine

53 TWILIGHT ON THE PLUM ISLAND RIVER

Charcoal and colored chalks on white wove paper. 10⅞ × 21⅞.

PROVENANCE: Private collection, Maine, up to 1964; Marvin Sadik, 1964; Victor Spark, New York, 1965.

LITERATURE: *Luminous Landscape: The American Study of Light, 1860–1875*, Fogg Art Museum, Cambridge, 1966, no. 19, illustrated; Theodore E. Stebbins, Jr., *Martin Johnson Heade*, Museum of Fine Arts, Boston, University of Maryland Art Gallery, College Park, Maryland, and Whitney Museum of American Art, New York, 1969, no. 55, illustrated; James T. Flexner, *Nineteenth Century American Painting*, New York, 1970, illustrated, pp. 84–85.

Anonymous lender, Branford, Connecticut.

Martin Johnson Heade was one of the major American landscape and still-life painters of the nineteenth century. Although he travelled to Europe and Latin America several times and produced a large number of paintings of hummingbirds and exotic flowers, his favorite subject was the places where the sea and the land meet, especially the seashore and the salt marshes of the eastern United States.

The present drawing of the Plum Island River, near Newburyport, which shows the hay stacked on poles above the tide line, is from perhaps his most powerful series of works, dating from ca. 1862–1868, including a watercolor and six charcoal drawings, of which this is the next to last (for others in the series, see Theodore E. Stebbins, Jr., *Martin Johnson Heade*, University of Maryland, 1969, nos. 53–56). Heade's reputation was beginning to be established in the early 1860's and in 1863 he made the first of his trips to Latin America, particularly Brazil; his first major marsh scene was in 1863. Heade catches the silence and isolation, even foreboding, of the marshes in this powerfully restrained drawing, without resorting to the melodramatic device of two owls silhouetted against the night sky that he used a few years earlier (Stebbins, no. 8). Although the artist's repertoire of subjects was limited, his concentration on the locale of the marsh, and even on this particular scene, resulted in this extraordinarily intense vision of sailboat and birds moving to the right while the sunset light, controlled but radiant, spreads across the sheet from the left.

54 FIGURE STUDIES

Graphite on white wove paper. 8⅝ × 10¹⁄₁₆.
Signed in graphite, *E. J. | 1863*; lower right, smudged, *EJ*. Verso, in graphite, *Hirschl + Adler 5742*.
PROVENANCE: Whitney Museum of American Art; Hirschl and Adler, New York.
LITERATURE: Patricia Hills, *Eastman Johnson*, Whitney Museum of American Art, New York, 1972, p. 39.

Anonymous lender.

Eastman Johnson was a major figure in the transition of nineteenth century American painting "from the circumscribed and provincial style of Edmonds and Matteson to the open, painterly style of Duveneck and Chase, from the nativist subject matter of Bingham and Mount to the themes of self in the paintings of Homer and Eakins" (Hills, p. 117). Johnson began his career in his early twenties as a portrait draughtsman and eventually acquired more formal training in the late 1840's and early 1850's in Europe, particularly in Düsseldorf, with Emanuel Leutze, the Netherlands, and Paris, with Thomas Couture.

Blacks and Indians were two major themes in his numerous paintings of rural genre scenes of the 1850's and 1860's, and the present drawing shows Johnson's ability to set down the image of a black youth, in his well-cut boots, jacket, and hat, directly, unsentimentally, and without condescension (for other such portraits, see Hills, pp. 46, 47, and for the general theme of the black, see Marvin S. Sadik, *The Portrayal of the Negro in American Painting*, Bowdoin College Museum of Art, Brunswick, 1964). Also during the Civil War, Johnson did three versions of a scene he witnessed himself, a fugitive slave family escaping on a galloping horse (Hills, p. 43). This drawing is typical of Johnson's mature drawing style of the 1860's and 1870's, not only in its firmly outlined figures in solidly constructed poses and transparent shadows, but also in the way different figures are placed at different angles on the sheet.

55 FARM WOMAN DRIVING FOUR CATTLE, IN A FAN COMPOSITION. Verso: a farm woman driving a cow, in a fan composition.

Black chalk on laid paper. Watermark: two or three letters, in script, in monogram (*J, M, B* ?). The verso composition, which is also in black chalk, is upside down from the recto composition. 12¼ × 18⅞ (sight).

PROVENANCE: William H. Schab, New York.

LITERATURE: *William H. Schab Gallery*, catalog 33, New York, n.d., no. 187, pp. 192–193.

Anonymous lender.

Camille Pissarro was one of the most faithful Impressionists, the only artist to participate in every Impressionist exhibition; although in the 1880's he worked as a Neo-Impressionist, by 1890 he had returned to a style closer to his earlier sensibilities. The life of the peasant was a constant theme in his work, and his drawings, in black or colored chalks, of peasant women herding cows or harvesting (like those of Anton Mauve and The Hague school) clearly recall drawings of similar subjects by Millet.

The present drawing is related in subject to many of his prints, paintings, and drawings of the 1880's and 1890's (e.g., no. 1427, ca. 1888, in Lionello Venturi, *Camille Pissarro*, Paris, 1939). This extraordinary fan shape is, in fact, not uncommon in the artist's work; he did more than fifty, mostly dating between 1880 and 1890 (Venturi, nos. 1609–1664). Although none is precisely similar to the present composition, they often depict peasant women in the fields or herding cows. Venturi (p. 56) points out that these fans testify to Pissarro's tendencies toward decoration, with even some Japanese influence. Among other contemporaries, Degas did more than a dozen fan-shaped compositions, and Gauguin did one after a rectangular painting by Cézanne.

GUSTAVE DORÉ *Strasbourg 1832 – 1883 Paris*

56 SCENE FROM *THE RAVEN*

Graphite, black watercolor with steel pen and wash, grey wash, white gouache, and metallic gold wash on cream wove paper. 20⅜ × 13⅞ (sight).
Signed in black ink with steel pen, lower left, *G. Doré*; inscribed in grey watercolor and brush, upper left, *NEVER-MORE.*
PROVENANCE: Art market, New York, ca. 1960.

Anonymous lender.

Gustave Doré was an extraordinarily prolific illustrator; by the age of sixteen, he was on the staff of Philipon's *Journal pour Rire*, and in his career he produced an amazing number of prints, or rather, drawings for wood engravings, illustrating a wide range of books, from the Bible, Dante and Cervantes, to Rabelais and Coleridge and, in a remarkable series, Blanchard Jerrold's *London*, showing the life of London's poor. Beyond these prints, the core of his work, he also executed large paintings and sculpture, characterized, like all of his work, by an almost obsessive fantasy, energy, and intensity.

This drawing is a particularly important example of his work. It is the drawing used for the first illustration in his last book, Edgar Allan Poe's *The Raven*, published posthumously by Sampson Low, London, 1883; the American edition was published in New York the following year, with a title vignette by the American painter of, often, highly imaginative scenes, Elihu Vedder (Henri Leblanc, *Catalogue de l'Oeuvre Complet et Gustave Doré*, Paris, 1931, pp. 280–281; for an illustration of the wood engraving after this draw-ing, see Blanche Roosevelt, *Life and Reminiscences of Gustave Doré*, New York, 1885, opp. p. 488). Doré prepared twenty-six illustrations for this last book—another drawing for one of them, the fifth in the book, with a man pensively sitting before a fire, while a skeleton and cloudy images of women and angels crowd around his chair, is in the same collection as the present drawing. These last works are among the artist's finest, simpler, truly monumental, and without his obsession for detail; it is interesting that at his death, he was planning a series on Shakespeare, and had already begun work on *Macbeth*. Poe's writings, and particularly "The Raven," were especially popular among late nineteenth century French artists and writers; Manet's illustrations for it are among his most beautiful lithographs and are less melodramatic, more understated and suggestive, than Doré's intense evocations of Poe's horrific visions. In this instance, the wood engravers working from Doré's drawings are clearly weaker than those, such as the Panemaker's, who engraved his earlier books.

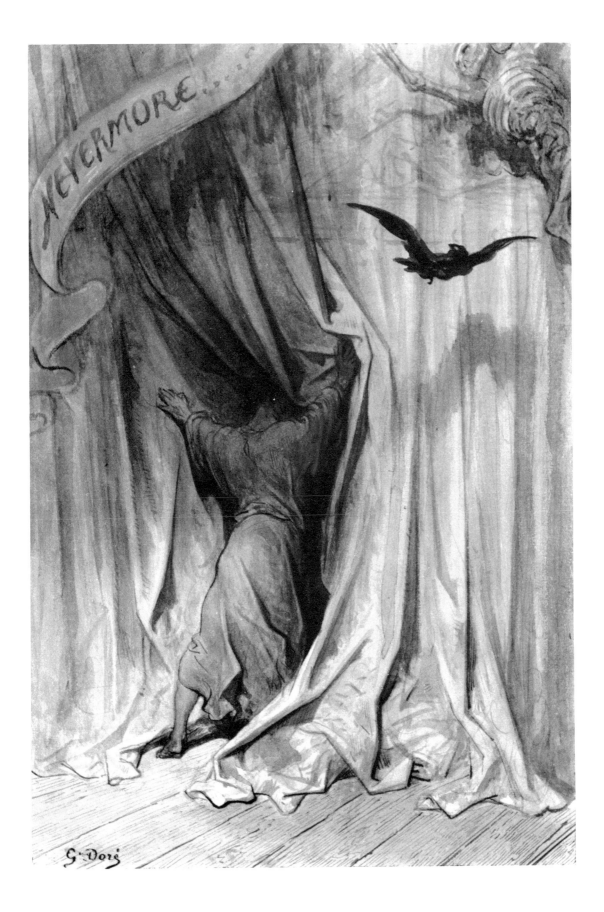

57 HEAD OF A WOMAN. Verso: unfinished drawing of the same woman and a small, faint graphite sketch of the bust of a woman.

Graphite on pale pink paper. The edges of the sheet are torn unevenly. Watermark: MICHALLET. Slight mat burn on all edges. 11⅜ × 9⅜.

Verso, atelier stamp in red (Lugt 657), *Degas*.

PROVENANCE: Galerie Mott, Geneva (1965).

LITERATURE: John Rewald, James B. Byrnes, and Jean Sutherland Boggs, *Edgar Degas: His Family and Friends in New Orleans*, New Orleans, Isaac Delgado Museum of Art, 1965, pp. 40–41, pl. XVII; *Selections from the Collection of Freddy and Regina T. Homburger*, Fogg Art Museum, Cambridge, 1971, no. 61, pp. 136–137. The technical data in the present entry have been drawn from the entry in the Fogg Art Museum exhibition catalogue, written by Agnes Mongan.

Freddy and Regina T. Homburger Collection, housed at the Maine State Museum, Augusta, Maine.

The four drawings by Degas in this exhibition present a good survey of the master's draughtsmanship; they range in date from the 1860's to the 1890's and show Degas's touch broadening from a thin pencil line, resembling a Renaissance silverpoint, to simple, bold strokes of charcoal, smudged and stumped. At the same time that the figures become more massive and more broadly executed (for a masterful analysis of Degas's graphic technique, see Theodore Reff, "The Technical Aspects of Degas' Art," *Metropolitan Museum Journal*, 4, 1971, pp. 141–166), they still remain emotionally distant, isolated, from us. The drawings also represent four of Degas's most frequent themes, the portrait, the jockey, the dancer, and the nude.

The present, early drawing, typical of Degas's cool, calculating eye, is probably a portrait of his cousin and, later, sister-in-law, Estelle Musson, ca. 1865. Estelle appears with her mother and sister in a major watercolor, dated 1865, in the Art Institute of Chicago, and again in a remarkably stark, small painting of the same year, in the Walters Art Gallery, Baltimore, one of Degas's most beautiful portraits, 1872, in the National Gallery of Art, Washington, and, perhaps in two or three other paintings and pastels (Jean Sutherland Boggs, *Portraits by Degas*, Berkeley, 1962, figs. 40, 41, and *Edgar Degas. His Family and Friends in New Orleans*, New Orleans, 1965, pp. 37–43). The reticence of this figure, almost an apparition, is reinforced by the flat, parallel shading on the right, drawn straight from the cheek through the hair into empty space, and, in this way, tending to flatten out the whole head into the sheet, with the thin, sharp, vertical lines of the hair drawn over it. Although it has become more sophisticated, the pencil technique of this work is still basically similar to such drawings of a decade earlier as his *Marguerite De Gas in Confirmation Dress*, 1854, in the T. Edward Hanley collection, Bradford, Pennsylvania (Boggs, fig. 6).

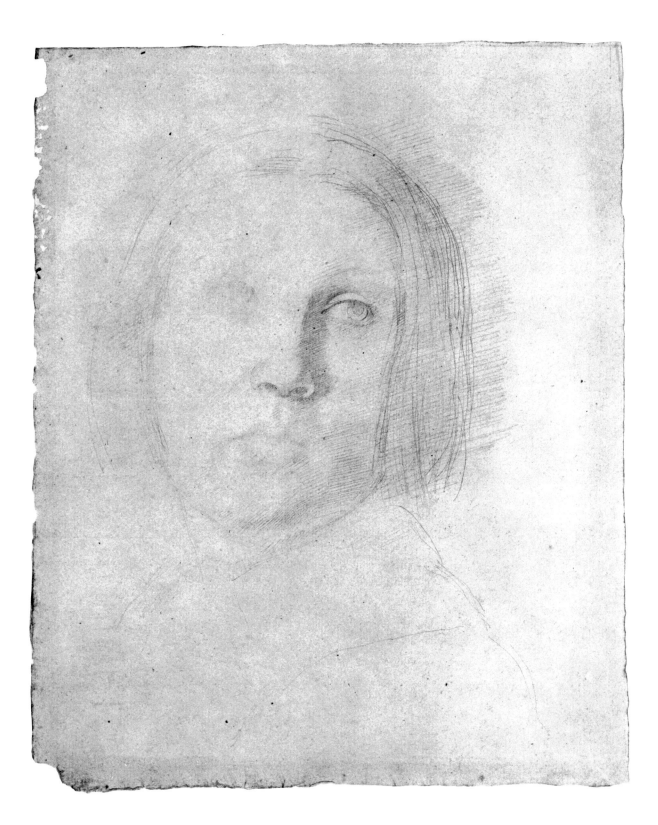

HILAIRE-GERMAIN-EDGAR DEGAS *Paris 1834 – 1917 Paris*

58 JOCKEY

Graphite on buff wove paper; laid down. 12¾ × 9¾.
Atelier stamp, in red, lower right (Lugt 658), *Degas*.
PROVENANCE: Weyhe Gallery, New York; W. G. Russell Allen.
LITERATURE: *Catalogue des Tableaux, Pastels et Dessins par Edgar Degas . . .* , 4th sale, Paris, 1919, no. 274 (one of two drawings of the same subject, dimensions, and medium, in the same frame; the present whereabouts of the other drawing, a jockey seen from the side, facing right, is unknown to this writer); exhibited, Pennsylvania Museum of Art, Fairmount.

Anonymous lender. P. Tunnard

This masterful group, beautifully placed on the sheet, illustrates Degas's interest in the world of the jockey and the racecourse. Although he clearly drew from life, he also turned to English sporting prints and paintings, Géricault, Delacroix, and even Meissonier (Theodore Reff, "Further Thoughts on Degas's Copies," *Burlington Magazine*, September, 1971, figs. 56–58, p. 538).

Although this drawing is close in style to a study from 1873 of a "gentleman rider" seen from the back, in the Edwin C. Vogel collection, New York (Agnes Mongan, *Great Drawings of All Time*, III, *French. Thirteenth Century to 1919*, New York, 1962, no. 782), it is still closer to a drawing of a jockey, of the same dimensions, in the Detroit Institute of Arts; in fact, the jockey himself is clearly the same person in both works. Jean Sutherland Boggs (*Drawings by Degas*, City Art Museum of St. Louis, 1966, p. 126) has pointed out that the Detroit drawing is a preparatory sketch for a figure on the far left in two paintings, one formerly in a private collection, Berlin (Lemoisne 387) and the other in the Louvre (Lemoisne 461), both from the middle or late 1870's. In both paintings, the figure in our drawing, turning in his saddle, also appears, on the right; in each case, a man in top hat, seen from the back, helps to close off the composition emotionally from us. For a survey of Degas's racing motifs, see Ronald Pickvance, *Degas' Racing World*, Wildenstein, New York, 1968.

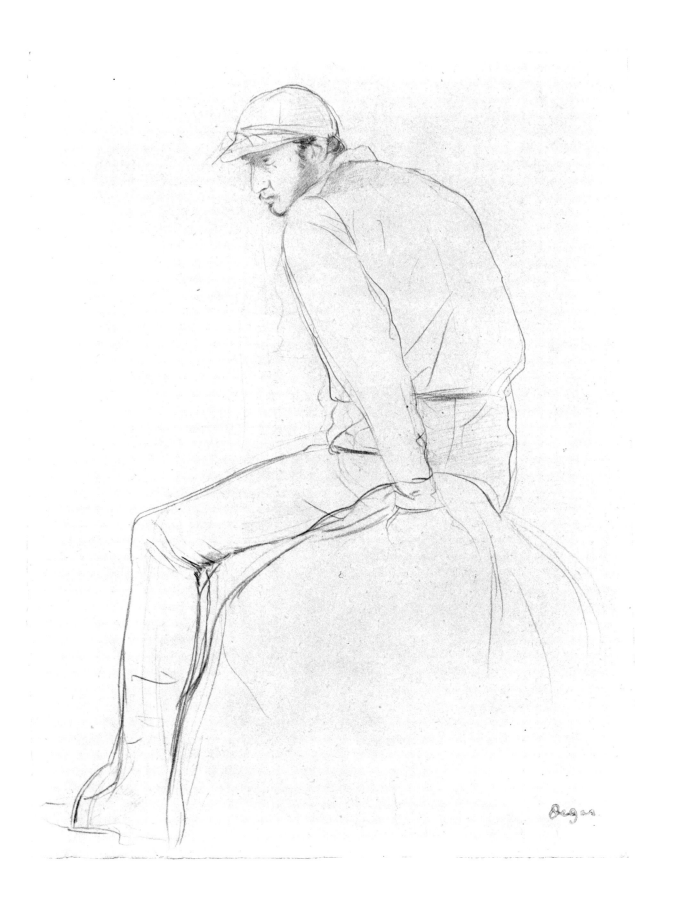

59 STUDIES OF A BALLET DANCER'S LEG

Black chalk and stumping on tan modern laid paper, frayed on the right edge, where it was attached to a notebook. Watermark: L. BERVILLE. 12⅝ × 9⅝.

Stamp, in red, *Degas* (Lugt 658); verso, in blue crayon, *2678*, and in blue crayon, by another hand, *pb (h?) 1156*. Verso of an earlier mount, a label, in pen and black ink, *Degas 11447 D | Etude de pieds | (dessin)*.

PROVENANCE: Henry McIlhenny; Paul J. Sachs.

LITERATURE: *Catalogue des Tableaux, Pastels et Dessins par Edgar Degas . . .* , 3rd sale, Paris, 1919, no. 81.1 (in the same frame with three other drawings of the same dimensions, all complete views of ballet dancers; the present whereabouts of the other three are unknown to this writer).

Anonymous lender.

This drawing is a preparatory study for Degas's painting, *Ballet Rehearsal*, from the late 1880's or early 1890's, in the Yale University Art Gallery (Lemoisne 1107); this painting is close to two others of this subject and period, in the National Gallery of Art, Washington, and the Sterling and Francine Clark Art Institute, Williamstown. Degas made close to a dozen drawings for the Yale painting, most of them for the key detail in the right foreground of the dancer pulling on, or adjusting, the tights on her right leg (listed by Lemoisne, 1107, with an additional drawing discussed by Jean Sutherland Boggs, *Drawings by Degas*, City Art Museum of St. Louis, 1966, p. 186, no. 122).

The present drawing is remarkable in that it includes on one sheet the solidly placed right leg of the dancer with her head in her hands in the center of the painting (here, at the top of the drawing), the upraised, beautifully graceful right leg of the seated dancer, who is adjusting her tights, and then, at the bottom, the left leg of the same seated dancer. The drawing is probably for the Yale painting rather than the Williamstown version (the Washington work does not include the standing dancer), since the pose of the left leg of the seated dancer at Williamstown has been made more vertical than it is here and at Yale. Degas seems to have had some difficulty with this left leg, to judge from the reworking of this detail in several of the preparatory drawings, and the diagonal lines in the lower right may be one more study of it. This drawing is the only one of the series to include parts of more than one figure and shows how the artist must have conceived of legs here as independent elements of motion and gesture.

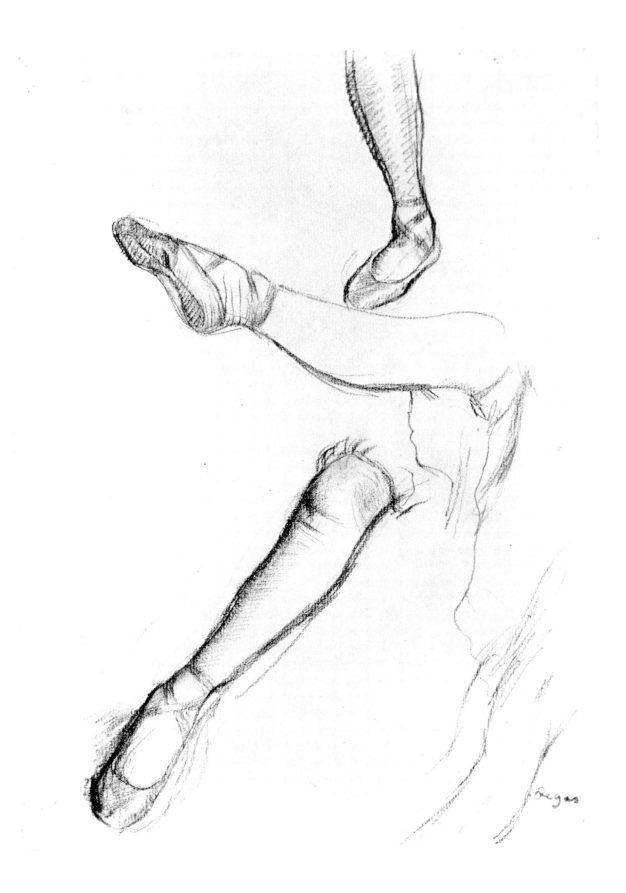

60 AFTER THE BATH

Charcoal with stumping on tan wove paper; vertical crease through the center. 18 × 23½.
Stamp in red, *Degas* (Lugt 658). Verso, stamp in red of the Degas atelier (Lugt 657); in graphite, *scène* de *guerre | serie sur femme de* (sheet edge).
LITERATURE: *Catalogue des Tableaux, Pastels et Dessins par Edgar Degas* . . . , 3rd sale, Paris, 1919, no. 202.

Wasserman Family Collection.

Degas found in nudes, and particularly women drying themselves after a bath, the same spontaneous, complicated poses, at the same time awkward and graceful, that he looked for in his studies of ballet dancers and, indeed, of jockeys and horses. He especially enjoyed seizing the figure as she leaned down to dry her leg; he executed another drawing almost precisely similar to this one in pose and dimensions, with the same hesitation over the line of the back and the head (2nd sale, Degas, Paris, 1919, no. 290), as well as various other studies (among others, Le-moisne 917, 918, 1074, 1380–1384). Although these drawings are sometimes dated from the 1880's into the first years of the twentieth century, the present large drawing is probably from the early 1890's, or perhaps the late 1880's; certainly, by the last years of the century, his stroke had become even broader, simpler, and more atmospheric, more "colorful," than it is here. (For a discussion of the drawing, mentioned above, that is most closely related to the present work, see Mario Amaya, ed., *A Tribute to Samuel J. Zacks* . . . , Art Gallery of Ontario, Toronto, 1971, no. 102.)

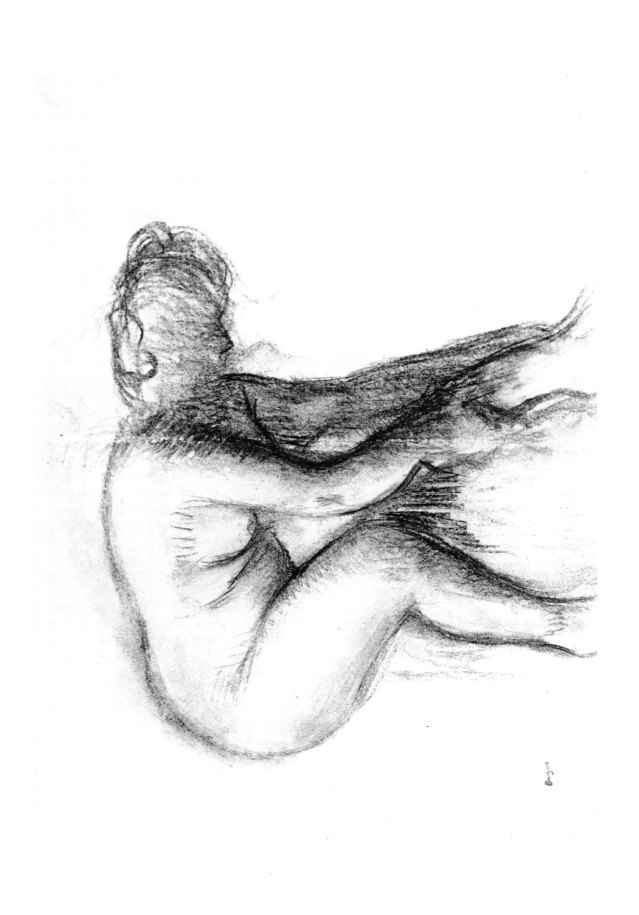

61 BOYS ON THE BEACH—GLOUCESTER

Graphite and colored washes, touches of black chalk, heightened with white, on modern, roughly textured white wove paper. 5½ × 13⅞.
Initialled in black chalk, *W H.*

PROVENANCE: Robert Macbeth, 1936.

LITERATURE: *150 Years of American Drawing 1780–1930 from the Collection of John Davis Hatch*, Williamstown, 1965, no. 27; Lloyd Goodrich, *The Graphic Art of Winslow Homer*, New York, 1968, cat. no. 80B, fig. 73 (detail); John Wilmerding, *Winslow Homer*, New York, 1972, p. 115, fig. 3-30.

John Davis Hatch Collection of Drawings by American Artists.

This fresh and charming drawing, with the white of the paper visible only here and there as highlights on the sail, hats, and parts of the figures, is related to a series of paintings and graphic works executed in the early 1870's; in the 1870's in particular, Homer was fascinated by the world of children and their relationships to nature and to adults and society in general, and here he has combined two themes, the building of a ship, in a painting in the Smith College Museum of Art, 1871, and boys on the beach, either holding model ships, in a painting of 1873, Art Association of Indianapolis / John Herron Museum of Art, or collecting wood chips and putting them in a basket, in the present drawing. In the final wood engraving, published in *Harper's Weekly*, October 11, 1873 (Goodrich, cat. 80, fig. 75), the boys are both collecting chips and holding their boats, while the ship being built looms up behind them.

The painting, *Boys in a Pasture*, 1874, Museum of Fine Arts, Boston, is also very close to this watercolor in its portrayal of a tight group of figures set against a deep, but flat expanse; the background serves more as a backdrop for the figures than as an environment containing them. The long horizontal format was used several times in the 1870's with this kind of subject (e.g., *Boys on a Fence*, 1874, Williams College Museum of Art), and the verticals of the pier behind and above the boys are typical of Homer's tendency to place unpretentious genre subjects within a classically composed structure, as in the *Sick Chicken*, Colby College Art Museum, and, most powerfully, *Waiting For Dad*, in the collection of Mr. and Mrs. Paul Mellon (see Barbara Novak, *American Painting of the Nineteenth Century*, New York, 1969, pp. 177–180). This fusion of the colloquial and the classical would result in the next decade, the 1880's, in some of his most monumental views of the sea and its threatening power.

62 STATUE OF MERCURY. Verso: sketch of a head.

Graphite on cream modern laid paper. Watermark: MICHALET. Tack holes in all four corners. 18¾ × 12⅛.
PROVENANCE: The Weyhe Gallery, New York (1937); W. G. Russell Allen.
LITERATURE: Lionello Venturi, *Cézanne*, Paris, 1936, no. 1451; *Paul Cézanne*, San Francisco Museum of Art, San Francisco, 1937, no. 64.; *Drawings and Watercolors from Alumnae and their Families*, Vassar College, 1961, no. 95; Adrien Chappuis, *The Drawings of Paul Cézanne*, Greenwich, Conn., 1973, I, p. 113, II, no. 305.

Anonymous lender. *J. Tunnard*

This masterful drawing, a fusion, in one sheet, of the balance and clarity of Poussin and the sensuousness of Delacroix, is an example of Cézanne's almost obsessive interest in copying a remarkable variety of works of art; although he copied many paintings, from Holbein, Rubens, Caravaggio, and Poussin to Delacroix, Couture, and Gérome, he was particularly interested in the intersecting volumes of figure sculpture, whether it was antique Roman or from the Strasbourg Cathedral, or Donatello, Michelangelo, Puget's *Hercules* or *Cupid* or *Milo of Cortona* (see no. 21), or the *Mercury* of the eighteenth-century Jean-Baptiste Pigalle (for a brilliant discussion of Cézanne's copies and their significance, see Meyer Schapiro, *Paul Cézanne*, New York, 1952, p. 98).

Cézanne made at least four other copies of this Pigalle, which is in the Louvre. Chappuis dates the present drawing 1873–1876 and the other copies (Chappuis, nos. 972 bis, 973, 974, 975) ca. 1890. This drawing is one of two, out of five, taken from the left side of this twisting, complex figure—the others look directly up into his face—and it is the most supple of all the versions, and the most conventional in the treatment of the figure's volumes. This pose, as beautifully placed on the sheet as a Degas jockey (no. 58, from the same collection), appears again in the other statues that Cézanne copied, such as Puget's *Hercules* and the antique *Crouching Venus*, and was used in his own figures of bathers. The original Pigalle, which was the artist's "morceau de reception" in 1744, was even copied in the eighteenth century, most notably by Chardin, who owned a plaster cast of it.

The small and unfinished sketch on the verso shows a head, perhaps female, leaning to her left, with hair flying upwards on either side, and various marks which suggest that if this is a copy, it is probably of a painting and not a statue.

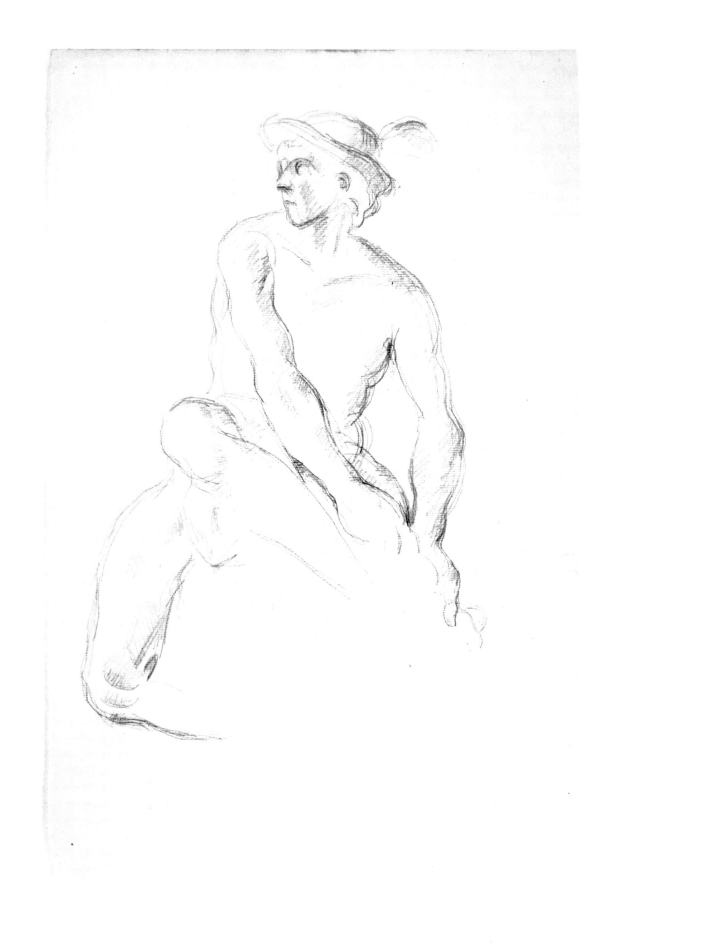

ODILON REDON *Bordeaux 1840 – 1916 Paris*

63 HEAD OF A WOMAN

Black chalk, with stumping and erasure, on tan modern wove paper. Watermark: *BERTHOLET FRERES A WESSE.* 19⅜ × 14⅝.
Signed in black chalk, *Odilon Redon.*

EXHIBITION: Cleveland Museum of Art, Walker Art Center, Minneapolis, 1951–1952, no. 26 (reproduced in the catalogue); Smith College Museum of Art, 1967.

Anonymous lender.

Although Odilon Redon remained outside the major movements of nineteenth century French art that he lived through, his extraordinary visions of disembodied figures in enchanted landscapes, inspired in part by an early friendship with Bresdin, earned the admiration of such widely different artists as the Impressionists, Gauguin and the Nabis, Matisse, and Marcel Duchamp.

His drawings are among his most extraordinary works; his rich blacks—in 1878 he went to the Netherlands to study Rembrandt—also transformed his lithographs, a medium to which he was introduced by Fantin-Latour in the 1870's. Although the present drawing is undated, these black chalk drawings of a young girl in profile, often set behind a frame or within a window or arch, seem to have been executed between the mid-1880's and the mid-1890's. One head, *Le Printemps*, can be dated to 1883 (Roseline Bacou, *Odilon Redon*, Geneva, 1956, II, no. 42), another, *Le Sommeil*, to 1889 (*Odilon Redon*, Matthiesen Gallery, London, 1959, no. 26), and another, *Illusion*, to ca. 1895 (*ibid.*, no. 28).

There are various similarly composed lithographs, such as one or two in the series, *Le Juré*, 1887, *La Lumière*, 1893, and *Brunnhilde*, 1894; and his painting, *Symbolic Head*, in the collection of Peter Andrews Putnam, Cleveland, was executed in 1890. The framing device seems to begin about 1890 (*Le Dessin français de Claude à Cézanne* . . . , Paris, 1964, I, p. 161).

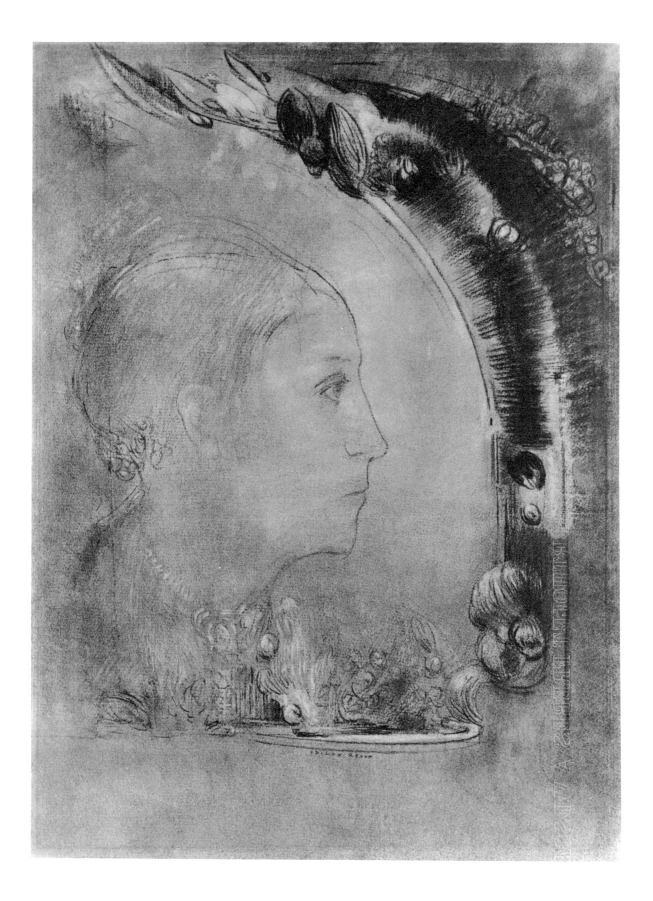

EDLON REDON

PIERRE AUGUSTE RENOIR *Limoges 1841 – 1919 Cagnes*

64 STUDIES OF GIRLS

Black, white, green, and pink chalks, on roughly textured modern laid paper. Watermark: *M B M*. 12⅛ × 17⅝.
Inscribed in graphite, lower right, *R*.
PROVENANCE: A. Vollard; Matthiesen, London.
EXHIBITION: Smith College Museum of Art, 1967.

Anonymous lender.

This charming sheet of sketches shows Renoir experimenting with young models in a variety of poses, suggestive of the lyrical view of women and nature that characterized his art from the 1870's to the end of his life. As he became more and more detached from the mainstreams of contemporary art, including Impressionism, his paintings and drawings became progressively looser and more spontaneous, and more repetitive of the themes of nudes or young girls in meadows, and so forth. The effect of this development on his drawings was less damaging than its effect on his paintings.

Although Renoir, at least until the 1880's, could execute a series of highly controlled and finished drawings for a major painting, such as *Les Grandes Baigneuses*, in the Carroll S. Tyson collection, Philadelphia, he more often turned to chalks and pastels on roughly textured paper, as in the present sheet. This drawing can be dated to the 1890's on the basis of its similarity to two preparatory studies for dated paintings in the Museum Boymans–van Beuningen, Rotterdam (H. R. Hoetink, *Franse Tekeningen uit de 19e Eeuw*, Rotterdam, 1968, nos. 226 and 227). Although the pose of the two girls in the upper right is reminiscent of a similar pair in a painting of 1887 (*Jeunes Filles Jouant au Volant*, Mrs. Huguette Clark, New York, Daulte 517), the two girls on the left, looking to the left, who are repeated in outline on the right of the sheet, are closer to paintings done ca. 1890, such as the *Two Sisters* in the Niarchos collection (Daulte 600).

142

65 THE POLEMAN IN THE MA'SH

Brown wash heightened with white, black chalk and graphite. Horizontal fold, 3⁹⁄₁₆ inches from the top edge, now rein-forced with tape on the verso; above this fold the pole (which is not reproduced in the book illustration) has been erased. Diagonal line in black chalk across the lower right corner. 11 × 5⁵⁄₁₆.

Inscribed in black chalk, *On block 3½ + 4½*; *The Poleman | In the Ma'sh* ——; verso, in italic letterpress, *This Picture is pre-sented to A. W. Drake* (the name in pen and brown ink) *| by THE CENTURY CO. , 18. | It has been engraved, published, and copyrighted by THE CENTURY CO., | NEW YORK, and must not be repro- | duced or published without consent.* Verso, in black chalk, *by Thomas Eakin* (sic); mark of the Held collection (H, J. and S in monogram, in black ink).

PROVENANCE: A. W. Drake; Berry-Hill Gallery, New York, 1966.

LITERATURE: Lloyd Goodrich, *Thomas Eakins, His Life and Works*, New York, 1933, p. 174, no. 151; *Selections from the Drawing Collection of Mr. and Mrs. Julius S. Held*, Binghamton, 1970, no. 5.

Professor and Mrs. Julius S. Held.

This drawing was used for one of the illustra-tions of an article, "A Day in the Ma'sh," by Maurice F. Egan, in *Scribner's Monthly*, New York, XXII, 1881, p. 348. The other illustra-tions included another by Eakins, the drawing for which is now at the Yale University Art Gallery (personal communication, Lloyd Goodrich), as well as others by J. W. Pennell and H. R. Poore.

This figure, called a pusher, is taken di-rectly from the figure on the extreme left in Eakins's *Pushing for Rail*, 1874, in the Metro-politan Museum; the scene of a hunter being poled through a marsh appears again in Ea-kins in *The Artist and his Father Hunting Reed Birds on the Cohansey Marshes*, 1874, in the col-lection of Mr. and Mrs. Paul Mellon, and *Will Schuster and Blackman Going Shooting*, 1876, in the Yale University Art Gallery, where the pusher is again a black. Eakins portrayed not only rural blacks, as in *Whistling for Plover*, 1874, in the Brooklyn Museum, but also the successful and gifted black painter Henry O. Tanner (Hyde Collection, Glens Falls).

Although his boxing compositions were executed in the late 1890's, most of Eakins's views of men hunting, sculling, sailing, swim-ming, or fishing, date from the 1870's or early 1880's; after that, he concentrated more on his sensitive portraits, usually of a single fig-ure, often with some sign of his profession close at hand.

For a general discussion of Eakins's illus-trations, including the present work, see Ell-wood C. Parry III and Maria Chamberlin-Hellman, "Thomas Eakins as an Illustrator, 1878–1881," *The American Art Journal*, v, 1, May, 1973, pp. 20–45.

On block 3½ x 4½

The Poleman
In the Ma'sh—

66 A SEATED ZOUAVE (MILLIET)

Graphite and brown ink with reed pen on cream wove paper; white gouache has been used for corrections in the costume and architecture. Watermark: J WHATMAN / TURKEY MILL / 1879. $19\frac{3}{8}$ × 24.
Signed at lower left in pen and brown ink, *vincent.* Verso, at lower right in pen and brown ink, *Vincent van Gogh | „Zouaaf" | „penteekening." | Echtheit von uns* VÖLLIG GARANTIERT. *| Artz* (?). *Bois | Haag. 30 Aug. 12*
PROVENANCE: Mev. J. van Gogh-Bonger, Amsterdam; Hugo Moser Gallery, Berlin; Max Lewin, Breslau; De Hauke, New York.
LITERATURE: Stedelijk Museum, Amsterdam, July-August, 1905, no. 383; J.- B. de la Faille, *L'Oeuvre de Vincent Van Gogh*, Paris and Brussels, 1928, I, pp. 135–136, no. 1443, II, pl. CLVI, no. 1443; Museum of Modern Art, New York, 1930, no. 106.

Anonymous lender. J. H. Brown

Van Gogh made this large and powerful drawing during his Arles period, in June, 1888. It was at this time that he discovered a particularly interesting model, this Arab soldier, a bugler, in his exotic and colorful costume; his delight with the zouave was recorded not only in a number of paintings and drawings but also in several letters to his brother Theo (nos. 501, 502) and to Emile Bernard (no. XI). In one (no. 501), he refers to the soldier in such words as "bull," "tiger," "feline," and calls one of his portraits of him "hard," "vulgar," "brutal," and "crude." Certainly, these qualities are present in this study, with its solid pose on a low chair, set down in the broad, relatively straight strokes typical of the reed pen.

The drawing is clearly related to his major painting of the zouave, in the Albert D. Lasker collection, New York; there are several differences between drawing and painting—for example, the hands are placed somewhat differently and the painted version lacks the pipe. There are, however, two major differences: the addition of huge, baggy, red trousers, to accentuate the drama of the pose of the legs, and, again, the transformation of the wall with an arch behind the sitter into a flat mass of white and the powerful emphasis on the design of the floor paving, sliding down parallel to the picture plane. The drawing is, in fact, more conventional in its treatment of space than the painting and seems a fairly quick notation from life, one of his first thoughts for the painting; certainly, it is less finished and less of a final preparatory study than his bust-length portrait drawing of the zouave in the collection of Mr. and Mrs. Justin K. Thannhauser, New York. There is, also, a sensitivity and even vulnerability in the eyes and mouth of the present drawing that are lost in the "brutal" painting.

Just two months later, Van Gogh was to start a series of portraits of another man, also seated and in uniform and with even more extraordinary hands, the postman Roulin.

THÉOPHILE-ALEXANDRE STEINLEN *Lausanne 1859 – 1923 Paris*

67 MARKET SCENE

Black chalk, with incised lines and extensive stumping, on tan modern wove paper; laid down. 19⅝ × 25⅜.
Signed in black chalk, *Steinlen.*

PROVENANCE: F. Bouisson; private collection, France.

Anonymous lender.

This impressive sheet comes from perhaps the most important group of drawings by Steinlen, all from the artist's friend F. Bouisson, President of the Chamber of Deputies, to whom one or two of the more than thirty drawings are dedicated (*Théophile-Alexandre Steinlen*, Dartmouth College, 1972). At his best, Steinlen is more than the relaxed, slightly sentimental illustrator that emerges from his views of Parisian street life and cats and other animals; he treated many subjects and was particularly drawn to scenes of poverty and hunger, often set down with a savagery reminiscent of other nineteenth-century artists concerned with social conditions, such as Forain, Doré, Guys, and, above all, Daumier.

GEORGES SEURAT *Paris 1859 – 1891 Paris*

68 MONKEY

Black crayon on white modern laid paper; laid down. Fragment of a watermark, MICHELET. 5½ × 9½.
PROVENANCE: Wildenstein and Co., New York.
LITERATURE: John Rewald, *Seurat*, Paris, 1949?, fig. 12; Biennale, Venice, 1950, no. 37; Henri Dorra and John Rewald, *Seurat*, Paris, 1959, p. 146, no. 134b.

Anonymous lender.

This gem is one of five extant drawings for a detail, a monkey on a leash held by a young woman, in one of the seminal paintings of late nineteenth century French art, *A Sunday Afternoon on the Island of the Grande-Jatte*, 1884–1886, in the Art Institute of Chicago. This sheet and the one of a monkey sitting up, in the Guggenheim Museum, are stylistically close to each other, in their simplified forms in silhouette, and are, perhaps, the most beautiful and most finished works in the series, rather than being study sheets. Already by the time of the oil sketch for this group in the Smith College Museum of Art, the monkey's forms have become stylized, particularly the tail, a tendency carried further in the final painting, where the monkey rears back and a small dog dashes forward as they catch sight of a larger dog to the left.

Seurat's drawings are a wonderful fusion of the precision and restraint of Ingres and the chiaroscuro subtleties of Millet, applied to everyday subjects, made monumental; here, as he usually does in his views of animals, Seurat has placed the figure parallel to the picture plane, with a bar of the cage dividing him in half and the cage itself making a built-in frame for the whole composition. The rough-textured paper, which keeps the crayon fragments on its upper surface, creates the effect of a figure without a clearly defined outline, subtly dissolving and solidifying into light and shadow, in much the same way that details in a Neo-Impressionist painting are composed of dots of colors that spread beyond the boundaries of their forms.

KÄTHE KOLLWITZ *Königsberg 1867 – 1945 Moritzburg*

69 STUDIES OF A WOMAN

Graphite on white wove paper. 17$\frac{15}{16}$ × 11$\frac{11}{16}$.
Signed in graphite, *Käthe Kollwitz / 1892.*
PROVENANCE: H. Shickman.

Anonymous lender.

This sensitive, reticent drawing, showing just a hand resting on a stomach and an ear and neck, comes from the beginning of Käthe Kollwitz's career, in 1892. In 1891 she had married Karl Kollwitz, a doctor who served a working-class district, in 1892 she bore her first son, Hans, and in the following year her work was to be exhibited publicly for the first time. She had abandoned painting for the graphic arts in 1890 and the prints of the early 1890's already have a directness and honest realism that were to be characteristic of all her later work. Nevertheless, working-class subjects, the horrors of poverty, death, violence, and industrial, urban society in general, did not begin to dominate her art until 1893, a tendency confirmed by her set of six prints based on Gerhart Hauptmann's play,

The Weavers, completed in 1898 and awarded a gold medal by Adolf Menzel (no. 52), later withdrawn by the Emperor.

These delicate studies are probably related to her etching with two-self-portraits of 1892 (Klipstein 9), which, in turn, is close to an etching with two self-portraits of the previous year (Klipstein 8). Both prints show the artist with her hand at her breast or on her stomach, and the work from 1891 also shows her in profile, with a view of her ear and neck. It is, however, possible that the hand in the drawing is supporting a child; mothers with their children were a constant theme in her work. Kollwitz's first print, in 1890 (Klipstein 1), was also a sheet of studies, with several views of a hand and another of just an ear.

70 SUMMER

Pen and black ink, black wash, graphite. The present drawing is made up of several sheets of paper: the strip $3\frac{1}{2}$ inches from the right edge is made up of three sheets of paper (the joins are $2\frac{13}{16}$ inches from the bottom and 5 inches from the bottom); another strip, $3\frac{11}{16}$ inches wide, has been added on the left; the central sheet is $11\frac{1}{4}$ inches wide. The two side strips completely contain the two female figures, although the pen lines of the drapery in both instances continue onto the main sheet. On the right, these pen lines are not precisely continuous on both sheets. The central sheet has been folded horizontally and vertically. The horizontal folds do not coincide precisely with similar horizontal folds on the two side strips; this suggests that the folds in all three sheets occurred before they were joined together into one large sheet. The vertical fold of the center sheet has been repaired with tape on the verso, as have a number of other damaged areas. Various pinholes. All five sheets are thin graph paper. $14\frac{1}{4} \times 18\frac{3}{8}$.

Inscribed in graphite, *84 216 1200.—Nr.92/238*; verso, in pen and black ink and graphite, a roughly rectangular geometrical design, with smudges of red paint, a woman's naked body, ruled lines, and other lines; inscribed in graphite, *2 63 303 –5*; by a later hand, *Kollo Moser (Vienna)*. Verso, mark of the Held Collection (H, J, and S in monogram, in black ink).

PROVENANCE: Sale, Dorotheum, Vienna.

LITERATURE: *Selections from the Drawing Collection of Mr. and Mrs. Julius S. Held*, Binghamton, 1970, no. 91.

Professor and Mrs. Julius S. Held.

Kolo Moser, until recently largely ignored, was a part of the remarkable flowering of art and culture that occurred in Vienna in the decade or so around the year 1900. The most brilliant of the artists at this moment included Gustav Klimt and Egon Schiele, as well as the young Oskar Kokoschka, and in this drawing Moser clearly shows his debt to the *Jugendstil* of the 1890's in the long decorative curves of the main panel and the floral wreaths held by the two girls. The pubescent girls, along with the figure's death-like sleep, suggest the influence of Klimt's tortured, erotic sensibility.

The collector has informed us that this is the only known preparatory drawing for a print, an allegory of Summer, the *Allegorien und Embleme*, ed. Martin Gerlach, Gerlach und Schenk, Vienna, III, pl. 51 (vol. III is entitled, "Allegorien, Neue Folge," and appeared 1895–1900). The finished print was illustrated in the catalogue Ch. M. Nebehay, *Kolo Moser*, 1971, n. 41 (see also Werner Fenz, "Kolo Moser und die Zeitschrift *Ver Sacrum*," *Alte und Moderne Kunst*, 108, Jan.–Feb., 1970, p. 28). In the final print, one of Moser's finest, the girl in the central panel has acquired butterfly wings, and the panel with the sleeping figure has been replaced by one with three kneeling, nude butterfly girls; also, various decorative elements, including trees, flowers, and wreaths have been added.

EDOUARD VUILLARD *Cuiseaux (Saône-et-Loire) 1868 –*
1940 La Baule (Loire-Inférieure)

71 A WOMAN AND CHILDREN IN A LANDSCAPE

Colored chalks and washes, gouache, on modern wove paper; laid down. Horizontal fold. The composition is arched. $17\frac{15}{16} \times 13\frac{3}{4}$ (irregular).
Studio stamp in black ink (Lugt 909c), *E.V.*
PROVENANCE: Gutekunst and Klipstein, auction no. 83, 1956, no. 337.
EXHIBITION: Smith College Museum of Art, 1967.

Anonymous lender.

Edouard Vuillard was a major figure in the Nabi group of the 1890's, using large areas of flat color to create a flat, decorative design over the whole painting. Seurat's pointillism, with objects at different depths reacting to each other coloristically, is carried further until, as in Gauguin, the figures become, merely, separate color areas within the tapestry. Wallpaper designs and mirrors are used to enhance this effect, influenced also by eighteenth century Japanese woodcuts, and the paintings themselves were often used in series of wall-panel decorations. The Nabis broke up as a group soon after 1900, and the best work of Vuillard himself was over by the time of the development of Cubism later in the decade.

Bonnard and Vuillard remained separate from the other Nabis in their choice of subject; instead of simple peasant scenes or religious compositions, they turned to the everyday Parisian bourgeois life around them. Vuillard was particularly attracted to views of gardens and public parks, perhaps inspired by Monet, and some of his most important commissions of the 1890's, for example, for the Natanson apartment in 1894, were dedicated to this subject. The present drawing can be dated to about 1900–1901, due to its similarity to a lithograph of 1901, a view of the garden from his studio, and the large gouache study for it in the Museum of Fine Arts, Boston.

72 TWO SKETCHES OF A WOMAN'S HEAD

Graphite with stumping and erasure on white wove paper. Watermark: *P. M. Fabriano*. 10¼ × 15¾.
Signed, in graphite, lower right, *Henri-Matisse*. Verso, upper left, in graphite, *No. 14*.
PROVENANCE: H. Reinhardt and Son, New York, December, 1929.

Anonymous lender.

The model is Antoinette, the nineteen year old who posed for Matisse in Nice ca. 1919–1920. She is most familiar wearing a Matisse hat in the Minneapolis *White Plumes* painting of 1919 and two variants, one in Goteborg, the third reproduced by Alfred H. Barr, Jr. (*Matisse, His Art and His Public*, New York, 1951, p. 427). Sixteen drawings of her in this hat are known to Victor Carlson (*Matisse as Draughtsman*, Baltimore, 1971) who includes four (nos. 34–37) in addition to a straight portrait (no. 33). All these drawings reveal Matisse's special interest in her distinctive nose and full lips. He lingers over these specifics in his drawings, softening their irregularities in the numerous paintings.

In various states of costume and undress Antoinette dominates Matisse's figure painting in 1919–1920. In some, such as *Meditation* of 1920 (Barr, p. 434), her disguise is so nearly total that only her strong chin, and related drawings of her in the same props, disclose that she is indeed the model. But in the important 1919 *French Window at Nice* in the Barnes Foundation (ill. in Barr, p. 425), her long angular face and figure are unmistakable. Matisse posed her again after the plumed hat series in a remarkable painting in the Hahnloser collection, Bern, *The Black Table* (Barr, p. 430). Here she wears a close-fitting cap; it is clear, however, that she still retains her long hair which Matisse had elaborated in his earlier drawings. Most striking about the present drawing is that Antionette has had her tresses cut more in keeping with the emerging flapper fashion. This drawing was made near the end of her modelling for Matisse and after *The Black Table*, painted in the summer of 1919. Three drawings of Antoinette with bobbed hair are illustrated in Waldemar George, *Henri-Matisse: Dessins*, Paris, 1925, pls. 36, 38, 39.

Louis Aragon (*Henri Matisse: A Novel*, New York, 1972, II, pp. 103–109) relates that it was Antoinette who still most fascinates him, of all Matisse's beautiful models, and speculates on the possible reasons she lasted only a year or less. "Could it have been because such innocence embarrassed him that Matisse kept Antoinette for so short a time?" (p. 109). Barr stresses her metamorphoses: pudgy, elegant, cool, childlike. He reports further (p. 106, note 8) that two paintings he had dated to Nice (including *The Black Table*) were actually painted in Issy-les-Moulineaux: Matisse, in an exceptional move, had brought Antoinette from the Riviera back to Paris in the summer of 1919. For these reasons, together with the unmistakable short hairdo, the present sheet should be dated to late 1919, possibly 1919–1920.

The silvery, medium hard pencil technique on a dense smooth paper is characteristic of Matisse's early Nice-period drawings in which a renewed interest in tonal values and volume is apparent in drawings as well as paintings.

JOHN HALLMARK NEFF

HENRI MATISSE Le Cateau (Nord) 1869 – 1954 Nice

73 THREE WOMEN

Pen and black ink on modern wove paper with a deckle edge; laid down. Pinholes in all four corners. 14¹³⁄₁₆ × 20.
Signed, lower left, in pen and black ink, *Henri-Matisse 1928*; inscribed lower right in graphite, then erased, *1928-Henri-Matisse.*

PROVENANCE: Saidenberg Gallery.

LITERATURE: Florent Fels, *Henri-Matisse*, Paris, 1929, pl. 4 (the illustration shows the graphite signature, lower right, before it was erased).

Anonymous lender.

John Hallmark Neff (letter, February 23, 1973) has pointed out that this drawing is one of a series done in Nice in 1928 using, for Matisse, a very unusual grouping of *three* models; the decor and poses make these his most explicit analogies to nineteenth-century paintings of the interiors of harems, the single odalisques having less obvious reference to a specific locale: they are only generally "oriental." The subject, Neff goes on, may also indirectly suggest the lesbian themes conveyed by means of harem interiors by such artists as Gérome; such themes had provided, by their familiar "deux amies" titles, a convention for two female figures in embrace or at least close proximity, all poses of considerable interest to a student of the human form, as Matisse was.

The drawing is very close to a painting, also dated 1928, *Odalisque*, in the collection of Mr. and Mrs. Ralph Colin, New York (*Matisse*, Hayward Gallery, London, 1968, no. 9), with the same contrast of vertical on the left and horizontal on the right, as well as such elements as the wallpaper and the chessboard. Another drawing, *Odalisque*, in the Cone collection, Baltimore Museum of Art (Victor I. Carlson, *Matisse as a Draughtsman*, Baltimore Museum of Art, 1971, no. 46), is clearly related in subject and style to the present work and has the same media and dimensions. This drawing provides a remarkable contrast with the other by Matisse in this exhibition, here in pen and ink rather than graphite, dependent on line only, but still focussed on the world of women.

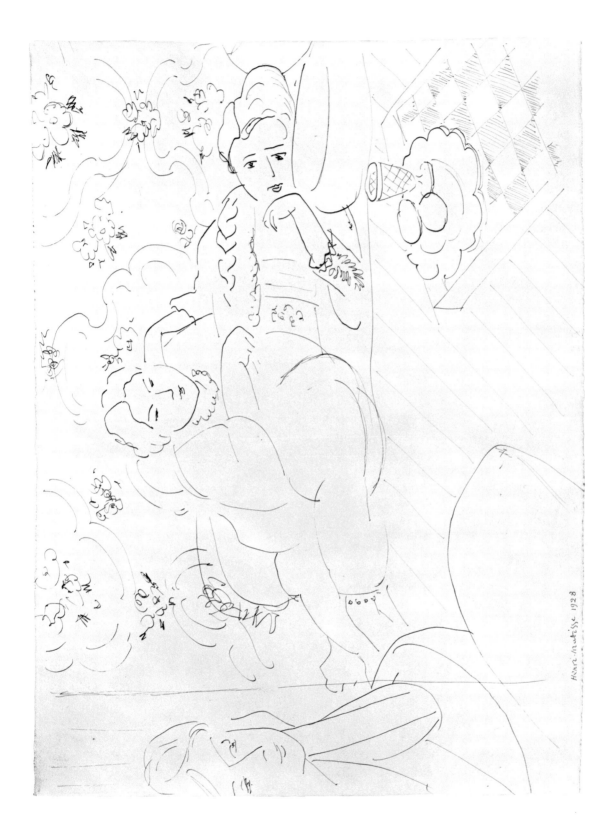

74 APPLE TREE

Charcoal on light grey paper. 18⅞ × 24¾.
Signed in charcoal, lower left: *P. MONDRIAAN.*

Anonymous lender.

The present drawing and another, S:c.c.190 (M. Seuphor, *Piet Mondrian: Life and Work*, New York, n.d. [1956], see pp. 357–395), are the only known drawings (or paintings) representing (or derived from) tree motifs which apparently post-date Mondrian's first stay in Paris, 1912 to early 1914. Both belong to the so-called "plus and minus" phase of ca. late 1914–1916, which culminated in the painting *Pier and Ocean* (S:c.c.239) and *Composition: 1916* (S:c.c. 232). The latter two paintings derive from a series of drawings based respectively upon beach piles extending into the sea (S:c.c. 234–238) and the façade of the church at Domburg (S:c.c. 252–257, but *not* 258). For illustrations of both motifs in nature (the *Pier and Ocean* drawings also were made at Domburg, Walcheren, ca. 1914–1915), see Welsh and J. Joosten, *Two Mondrian Sketchbooks*, Amsterdam, 1969, page 12.

It is unknown whether or not the two "tree" drawings were also done in Domburg or elsewhere from nature, or either from memory or other earlier preserved sketches. A close friend of Mondrian, Mr. A. P. van den Briel, once recalled for me that during the years of World War I, Mondrian did on one occasion return to the theme of a tree for a major painting, which canvas, however, has not been identified. In any case, the two drawings do definitely indicate that Mondrian intended to produce a final tree painting during the war years, whether or not it was ever completed, since this function is attributed to all his drawings of this period by Mondrian in an unpublished letter to a patron, the Reverend H. van Assendelft. (It is also implied by the "scumbling" technique, which produces a "painterly" effect in smudges between the lines.) Conversely, the configuration of curved lines in the present drawing, according to my reading, reflect still the "Apple Tree" as found in a series of drawings and paintings from ca. 1912 (S:c.c. 175–177 and 179). Thus, it is possible that Mondrian merely stylized this familiar motif from memory or a sketch rather than worked from nature.

In any case, this tree motif is conceived with an emphasis on the horizontal, including the picture format, in contrast to numerous vertical trees (e.g., S:c.c. 192, 196, and 198), which horizontal thrust is also dominant in the background "plus and minus" lines. Hence, in iconography the feminine, material polarity is emphasized over the male, spiritual one.

ROBERT P. WELSH

KASIMIR MALEVICH *Kiev 1878 – 1935 Leningrad*

75 COMPOSITION

Graphite on tracing paper (*papier calque*). There is a faded indication of a blue printed grid over the right two-fifths of the sheet. The design area occupies only the left two-fifths of the sheet. The right two-fifths is creased and was probably originally folded back. 3⁹⁄₁₆ × 6⅛.

Inscribed in graphite below the design area at the right, *15 cm* (?); inscribed in graphite to the right of the design, *14 cm* (over *15 cm* with *5* altered to a *4*); inscribed in green ink at the right, *102*.

LITERATURE: K. Malevich, *Suprematism. 34 Drawings*, Unovis, Vitebsk, 1920.

Mr. and Mrs. Stephen D. Paine.

Kasimir Malevich's career went through a variety of phases, sometimes overlapping. His early Impressionist portraits and landscapes were succeeded, in the years 1907–1911, by a series of large, bright canvases, with simply painted, crudely outlined figures, that are reminiscent of contemporary German Expressionism. From about 1911 to 1913, these figures are subtly transformed into smooth, simple constructions of cylinders and other geometrical forms, much like Leger's mechanized abstract forms or, later, men and women; Malevich's figures are still identifiably Russian, chopping wood or walking down village roads. In 1912, he spends a month in Paris, and for the next two years his work is clearly under the influence of Cubism. However, already in 1913/1914, his first Suprematist compositions are being executed, with their complete abstraction and simplification of forms, as we see in the present drawing. This brilliant and intense period culminates in his famous series of paintings of 1918, *White on White*, after which he did not paint again for almost a decade.

In 1918 Malevich was invited by Chagall to the art school in Vitebsk and eventually became its dominant figure, after Chagall had left. With El Lissitzky, he reorganized the school and named it Unovis; it was here that he published his various books, including the one which reproduces the present drawing. His last works, in the 1930's, are large, primitive, realist portraits.

Malevich published several books and essays—some, such as "The Suprematist Mirror," of an extraordinary eloquence and simplicity—and one of them, without text, is the book of thirty-four drawings, of which our drawing is the twenty-eighth. This wonderfully delicate and precise imaginary landscape, which looks forward to Kandinsky's classic series of prints of 1922, *Kleine Welten*, is part of a series of drawings done over the previous five or six years (ours is ca. 1915) but arranged in a careful sequence in the book. The first drawing is a large black square which is followed by a black circle, then a black cross; in the next few drawings, the squares are slightly twisted out of shape, made smaller, placed at one end or another of the sheet, and eventually, other forms are added to them. The square itself is broken up, stretched, set at different angles, shaded instead of solid, and, as in our work, more and more smaller forms are added to the composition. Finally, in the last seven or eight drawings, the rectilinear diagonals become curved forms, which eventually dominate the composition. The last drawing is a powerful diagonal intersected by three curves, like an arrow on three bows. (For a reproduction of the book, see K. S. Malevich, *Essays on Art, 1915–1928*, I, Copenhagen, 1968, pp. 129–164.) Our reproduction shows only the design area, rather than the whole sheet.

PAUL KLEE Bern 1879 – 1940 Muralto-Locarno (Switzerland)

76 SUICIDE ON THE BRIDGE

Pen and black ink on white modern paper; laid down by the artist onto its mount. Paper, 6⅜ × 4⅞.
Signed in pen and black ink on the paper, *Klee*; inscribed by the artist on the mount in pen and black ink, *1913 100 Selbstmörder auf der Brücke.*

Anonymous lender. J. MacAndrew

The two drawings by Paul Klee in this exhibition express beautifully the sensitive and brilliant personality of this artist, who was associated with such major movements of twentieth-century art as the *Blaue Reiter* and the *Bauhaus* but who always managed to stay independent of them. The present drawing was executed in 1913 when the artist was living in Munich and beginning to be successful in Germany and Switzerland, for the first time in a circle of friends who understood and admired his work; he was included in the *Sturm* exhibition in Berlin in this same year, and the year before his prints had been included in the second *Blaue Reiter* show.

The present drawing shows a man in a top hat poised like a high-wire trapeze artist on a network of thin lines; beneath his feet is a huge clock, and beneath the clock a grimacing face, and to the sides, a smaller face and, interestingly, a double-headed eagle. The design shows a more imaginative fantasy than his drawings of three or four years earlier, with views of railway stations, forests, and quarries, but his lines are still made up of shorter lines strung together, creating a scratchy, disjointed effect, as in his *Sketch from Kairouan*, 1914, in the Klee Foundation, Bern.

166

1918 160 Selbstmörder auf der Brücke

77 ELEPHANT AND LION

Rose, blue/violet, and brown watercolors, black ink, white gouache on modern white laid paper; laid down by the artist onto its mount. The artist has drawn a black ink line on the mount just above and below the drawing sheet. Design sheet: 12⅛ × 18⅜; mount; 18½ × 24.
Signed lower right in black ink, *Klee*. Inscribed in black ink on the mount below the drawing's lower left corner, *1926 o. 6* (underlined); below the drawing's lower right corner, *Elefant und Loewe* (underlined).
PROVENANCE: Parke-Bernet, New York, December, 1967.

Anonymous lender.

On a trip to Tunis in 1914, Klee had, as he said, discovered color and discovered himself to be a painter, and this discovery was to shape his work for the rest of his career; a trip to Egypt in 1928 was to have almost as great an effect on him. This drawing, done in 1926, belongs to a substantial group of works executed between 1925 and 1929 that contrasted tight, wiry forms, done in pen and black ink, with a hazy atmosphere of pulsating, shifting fields of color over the whole sheet. Among these works are the painting, *She yells, we play*, 1928, Klee Foundation, Bern, and the watercolors, *Static—dynamic—opposite*, 1926, Nika Hulton Collection, *Monsieur Perlenschwein*, 1925, Kunstsammlung N. W., Düsseldorf, and *What a Horse!*, 1929, art market, Lucerne. The present drawing, with its lion barely emerging out of the colors to threaten the elephant, was probably executed in Dessau, where he and his family had moved by July, 1926, in anticipation of the reopening of the Bauhaus there later that year.

ERNST LUDWIG KIRCHNER *Aschaffenburg 1880–1938 Frauenkirch, near Davos*

78 NUDE WOMAN. Verso: two nude women.

Black ink with reed pen and brush on white wove paper; the verso is drawn in pen only and is upside down from the recto composition. 15¾ × 13.

Stamped on the verso in purple, (—?—) *83 | KIRCHNER*, in a rectangle with *Bg 80* inscribed within the rectangle in graphite. Verso, inscribed in graphite, *7/31 4530 898*.

PROVENANCE: R. M. Light, Boston.

Mr. Edmund P. Pillsbury.

Ernst Ludwig Kirchner, with Erich Heckel and Max Pechstein, was one of the major figures of the German Expressionist movement, *Die Brücke*, and the present drawing is typical of Kirchner in its sharp contrasts of areas of black ink and white paper, the flat, angular forms of the breast, the straight, sharp, lines that define the nose, eyebrows, and eyes, and, in the verso, the abbreviated shorthand and interrupted lines of the two nudes. The drawing is, in these ways, typical of many of Kirchner's nudes of 1909 and 1910, when he began to be influenced by African and Polynesian art; by 1912 and 1913, his nudes become longer and thinner, more awkward, nervous, and stylized, and they exist in shallower space.

This drawing is, in fact, a preparatory study for a double-sided painting in the art market, Campione (Donald Gordon, *Ernst Ludwig Kirchner*, Cambridge, 1968, no. 177 and 177v). The recto of the drawing, of a single nude, is for the verso of the painting, while the verso of the drawing, with two nudes, is for the recto of the painting. The single nude is unusual for Kirchner in its almost radiant health and happiness, very different from, for example, the contemporary *Marcella*, in the Moderna Museet, Stockholm.

79 STANDING NUDE WOMAN

Black ink with pen and brush and red gouache on white modern laid paper. Watermark: CF with a caduceus in a shield and *Ingres 1871* (fragmentary mark and countermark). There is a band of brown paper tape around all the edges of the drawing; this has been omitted from the reproduction. 25 × 17¾.
Verso, signed in graphite, *Picasso* (underlined).

Anonymous lender, through the Fogg Art Museum.

The three drawings by Picasso in this exhibition take us through the master's most creative decade, 1906–1908 to 1918–1920. The first of the drawings is this monumental nude, probably dating from 1906, the year before his *Demoiselles d'Avignon* was completed. Already, in this work, the artist has begun to simplify his forms, making them more massive and abstract, viewed, frequently, from below. The static poses, unemotional faces, and restrained gestures are characteristic of many of these drawings and paintings, for example, the *Seated Woman and Standing Woman*, in the Arensberg Collection, Philadelphia Museum of Art.

Already by 1907 the straightforward simplicity of works like these has yielded to a stylization of the body into flat masses whose joints form harsh angles; the figures become rough-hewn wooden sculptures, and by 1908 the planes of the body slide into each other and into the planes of the empty space around it.

The head of this woman is particularly close to other works of 1906 and the winter of 1906–1907 (Zervos, I, no. 347, and II, 2, nos. 601, 604, 605.).

PABLO PICASSO *Málaga 1881 – 1973 Nôtre Dame de Vie*

80 HEAD

Charcoal with stumping and eraser work and graphite on a collage of various laid papers and yellowed newsprint on white modern laid paper. What appears to be grey wash may be glue stains. The entire sheet has been laid on a mount with a rectangle cut at the upper right to reveal the artist's signature on the verso. Watermark: on the main sheet, *Ingres*; on an applied paper, . . . *res 186* . . . (*Ingres 186?*). 22½ × 18¾.
Verso, signed in graphite, *Picasso* (underlined); printed, *280*; stamped in black, in a circle, EXPOSITIONS DOUANES.
PROVENANCE: Tristan Tzara.
LITERATURE: Christian Zervos, *Pablo Picasso*, Paris, 1942, II, 2, pl. 190, no. 400.

Anonymous lender.

The extraordinary transformation that Picasso underwent in the few years since the previous drawing is documented in this powerful collage drawing of 1912. The work is typical of the many heads and still-lifes the artist did in this year, especially the remarkably similar *Man with a Hat*, December, 1912, in the Museum of Modern Art, New York, and another collage, *Man with Violin*, in the collection of Roland Penrose, London (Zervos, II, 2, no. 399). Picasso plays brilliantly here with our traditional conceptions of space, the picture plane, and pictorial reality: although the newsprint has been pasted on, above the paper, the lines of the face go directly over both media, without registering a change in space, while the vertical strip of paper in the lower right has an exaggerated shadow. The face itself, just sketched in and barely recognizable as such, is drawn, at least partly, on something utterly real and everyday, the newspaper (the fragment here has to do with an affair between Pierre Herbault and Juliette Moullon, ending, apparently, in divorce). The letters (like the flags, numbers, and targets of Pop Art almost half a century later) are images that have no illusionistic impact. By the end of 1912 and the beginning of 1913, Picasso's collages became even less figurative and more flattened out, reflecting a shift in style that becomes more apparent in the following drawing (for collages of 1912/1913, see *Picasso*, Tate Gallery, London, 1960, pls. 16b, 16c, 16d).

81 SHEET OF STUDIES, INCLUDING A LEFT HAND AND A GUITAR

Graphite on white modern laid paper. Watermark: three shapes suggesting sea turtles surmounted by a crown and surrounded by palm fronds. 12½ × 8½.
Signed in graphite, lower right: *Picasso* (underlined). Verso, inscribed in graphite, *N.47214* and *2057*.

Anonymous lender, through the Fogg Art Museum.

This beautiful drawing was probably executed in 1919 or 1920. Although the guitar had been a constant theme in Picasso's work from the beginning of Cubism, it assumed special importance in his paintings and drawings at the end of the second decade, particularly represented, as here, as a series of coolly defined, flat, overlapping planes. The themes of the guitar and the artist's left hand, once or twice in the same work, were among his most frequent from 1917 to 1920 (Zervos, III, nos. 446–458, and elsewhere, for drawings of hands, nos. 391–395, and 419, for similar treatments of the guitar, and Zervos, IV, no. 44, for the two themes together, 1920).

The synthetic cubist handling of the guitar, with its careful modulation of tones, is very different from the stronger, simpler analytic cubism evident in the previous drawing in this exhibition. What is unusual about this drawing is the addition of the hand (as if to play the guitar) in a style apparently very different from the rest of the drawing and from that of the nude, sketched in broad, straight strokes, in the first drawing by Picasso in this exhibition. The hand is an example of Picasso's neo-classical draughtsmanship at its best, just outline and no shading, with the white of the paper forming a ground. In fact, the hand and the guitars, in two different styles, have a similar feeling of restraint, delicacy, precision, and introspection; this drawing shows that Picasso's neo-classicism of the late 1910's and 1920's was not just one more aspect of the post-World War I reaction to the previous years' experimentation that is characteristic of so much French and German art. Rather, it is an outgrowth of stylistic concerns that transformed all of his art, both non-figurative and representational. Picasso's play with illusionistic volumes in space can be seen in the two objects at the bottom of the sheet, whose three-dimensionality is painstakingly built up, facet by facet, and then summarily denied by a line defining the side or the base; even these almost random forms reappear in a sheet of sketches of 1919 (Zervos, III, no. 462). In Zervos, III, no. 394, Picasso again draws on one sheet in both a classical and a cubist style.

MAX PECHSTEIN Zwickau 1881 – 1955 Berlin

82 AT THE SHORE

Watercolor and graphite on thick paper. 12⅜ × 16⅜.
Signed in graphite, *HM Pechstein 1919* (H, M, and P in monogram). Verso, mark of the Held Collection (H, J, and S in monogram, in black ink).
PROVENANCE: Morris Hillquit.
LITERATURE: Una E. Johnson, *20th Century Drawings, Part I, 1900–1940*, New York, 1964, p. 79, pl. 47; *Selections from the Drawing Collection of Mr. and Mrs. Julius S. Held*, Binghamton, 1970, no. 93.

Professor and Mrs. Julius S. Held.

Max Pechstein was part of the German Expressionist group, *Die Brücke*, in the decade just before World War I. However, he achieved his most powerful, and expressionist, work after leaving Germany and going to the South Seas in 1914 (as Emil Nolde had done); this experience affected not only his drawings and paintings but also inspired a series of extraordinary wooden sculptures in 1919, strongly derived from African forms.

The sea, and particularly the shore and the harbor, were a favorite subject of Pechstein's. The present drawing, with a couple holding hands and looking out to sea, is reminiscent of similar subjects by Edvard Munch; the theme of ships pulled up on the shore goes at least as far back in his career as 1909 (see Max Osborn, *Max Pechstein*, Berlin, 1920, opp. p. 40, and Walther Heymann, *Max Pechstein*, Munich, 1916, plates 8 and 9), and the life of the fisherman always fascinated him—in two paintings of 1917, he particularly focussed on the fishermen getting their boats into the sea and then back onto the shore. Two watercolors in the Busch-Reisinger Museum, Cambridge, both of this same subject and dated 1919, show the importance of this theme for Pechstein at this time.

GIORGIO DE CHIRICO *Volo, Greece 1888 –*

83 RECLINING FIGURE IN A CITY SQUARE—SOLITUDE

Graphite and gouache on modern wove paper; laid down. Pin pricks in the paper. $8\frac{11}{16} \times 12\frac{11}{16}$.
Inscribed by the artist in graphite, *G. de Chirico | 1917*.
LITERATURE: Filippo de Pisis, *Pittura Moderna*, Ferrara, 1919; *12 Opere di Giorgio de Chirico*, Rome, n.d., n.p. (reproduced); Paul J. Sachs, *Modern Prints and Drawings*, New York, 1954, p. 175; James Thrall Soby, *Giorgio de Chirico*, New York, 1955, p. 89.

Mr. Paul W. Cooley.

This is one of the most important drawings of the leader, with Carlo Carrà, of the Italian Metaphysical School. The work includes many of the elements typical of De Chirico's paintings in the second decade of the century: the various towers and smokestacks, the train station (and the train in the left background), the empty square, and, dominating it all, this monumental mannequin, on a pedestal, impersonal, unfinished, with various geometrical forms piled up behind it, and yet somehow introspective and melancholy, even vulnerable. The mood of the work is typical not only of De Chirico, Carrà, and other Italian contemporaries, such as Giorgio Morandi, but also seems related to earlier artists, for example, Piero della Francesca and Gustave Courbet.

This drawing is dated 1917, and it was, briefly, in this year that Carrà and De Chirico worked together in Ferrara creating the *Metaphysical* esthetic and when De Chirico executed some of his most important paintings, such as the *Grand Metaphysician* and the *Troubadour*. It was also the end of De Chirico's strongest period; at least partly by 1918, and certainly by 1920, his drawings and paintings had become looser, fuzzier, and more romantic, and more repetitive of his earlier themes.

84 PORTRAIT OF DR. ERNST WAGNER

Black crayon. 18⅜₆ × 11¹³₆.
Inscribed in black crayon, *Egon | Schiele | 1918*; also inscribed *E W* (for Ernst Wagner). Verso, in graphite, *Bildnisstudie Herr Dr. Ernst Wagner.*
PROVENANCE: Mrs. Jacob M. Kaplan, 1963.
LITERATURE: *Selections from the Drawing Collection of Mr. and Mrs. Julius S. Held*, Binghamton, 1970, no. 97.

Professor and Mrs. Julius S. Held.

This powerful and intense drawing dates from the last year of Egon Schiele's life; Schiele was intimately involved in the remarkable outburst of artistic and cultural achievement in Vienna in the early years of the twentieth century, centering around Gustav Klimt, by whom he was deeply influenced, Sigmund Freud, Gustav Mahler, Alban Berg, and Arnold Schönberg, of whom he did a portrait drawing in 1917. Schiele's late crayon drawings, and his lithographs, must have been one source for Oskar Kokoschka's most brilliant lithographs, for example, the portrait of Max Reinhardt, of about 1918–1920.

The present drawing is a part of a group of very similar portrait drawings of men, all from 1918, all in black crayon, including the portraits of Franz Blei (Historischen Museum der Stadt Wien) and Hugo Koller (Serge Sabarsky Gallery, New York), both of whose dimensions are precisely the same as those of the Held sheet, Paris von Gutersloh (Mr. and Mrs. D. Thomas Bergen, London, on extended loan to the Art Institute of Chicago), and Robert Müller (Serge Sabarsky, New York) (reproduced, *Egon Schiele and the Human Form*, Des Moines, 1971, nos. 59, 60, 58). It is possible to see in these last works a deepening and maturing of Schiele's art, and a lessening of the mannered poses, self-conscious decorativeness, and blatant eroticism of his earlier work.

85 GIRL JUMPING ROPE, WITH A BOY TO THE LEFT.
Verso, a girl jumping rope, with two boys.

Black ink with brush on cream wove paper. Watermark: WHATMAN 1936 ENGLAND. Areas on the verso have been sponged out to correct the design. 22 × 30.

PROVENANCE: Gift of the artist, 1945.

LITERATURE: James Thrall Soby, *Ben Shahn*, Middlesex, 1947, pl. 18, with the Boston painting, pl. 19; Paul J. Sachs, *Modern Prints and Drawings*, New York, 1954, p. 234; *The James Thrall Soby Collection*, Museum of Modern Art, New York, 1961, p. 64; exhibited, Santa Barbara Museum of Art, 1967.

Mr. James Thrall Soby.

Ben Shahn's basic social commitment is the common thread that runs through the various aspects of his career, from painting to commercial art to photography (he shared a studio with Walker Evans) to book illustration to posters (some for the Political Action Committee of the CIO and Henry Wallace's Presidential campaign); his subjects range from Sacco and Vanzetti to dispossessed farmers to Martin Luther King. He worked with Diego Rivera on his Rockefeller Center frescoes and was part of a group of American social realists of the 1930's, along with William Gropper and Peter Blume, who, in their turn, had an impact on such post-war Italian artists as Renzo Vespignani and Bruno Caruso.

His strongest work was, perhaps, from the late 1930's to the late 1940's (such powerful drawings as *Porch no. 1* and *Dancers* are dated 1947), and in many of these paintings and drawings, the dominant theme is of children or youths, playing a game of handball, on swings, in a vacant lot, or skipping rope. The present drawing, recto and verso, represents two of the at least three preparatory studies for his tempera painting of 1943, in the Museum of Fine Arts, Boston. The first thought for the painting seems to be a drawing in the Betty Chamberlain collection, New York (Selden Rodman, *Portrait of the Artist as an American. Ben Shahn*, New York, 1951, p. 61); here, the girl skips rope, but the boy, his back to us, is leaning against a lamppost, his arm around it. In the verso of the present drawing, the boy with his back to us has been moved to the left and another boy, facing us, has been put in on the right, further back in space. In the recto of this drawing, Shahn has worked out the final form of the idea; with a touch that is surer and simpler than before, he has added the remarkable detail of a ruined house behind the girl, thus giving her —and the boy to the left—greater emotional impact. In the painting, Shahn, perhaps unfortunately, adds a landscape behind the boy and the far walls of the ruined building, with flowered wallpaper.

86 COMPOSITION

Pen and black ink, gouache, graphite, on thick, tan, modern wove paper. Light-struck, with mat burn. The original color of the paper, still visible along the edges, was white. $22\frac{1}{16} \times 28\frac{1}{4}$.
Signed, lower right, in pen and black ink, *Yves Tanguy 52*.
LITERATURE: James Thrall Soby, *Yves Tanguy*, New York, 1955, p. 61; Una E. Johnson, *20th Century Drawings, Part II*, New York, 1964, p. 54; *Drawings and Watercolors from Alumnae and their Families*, Vassar College, 1961, no. 140.

Mr. H. Sage Goodwin.

Yves Tanguy's weird, unreal, and yet somehow tangible and familiar landscapes form a unique part of the Surrealist movement. Related to the work of Ernst and Dali, his paintings have overtones of a microscopic world, as well as of a moonscape, with these highly polished, brightly colored stones, set in intricate, purposeless constructions, in a landscape without a horizon line or even a clearly defined ground. The drawings, usually pen or pencil on white paper, are simpler, sparer, and often have the overtones of a construction of bones. They avoid the feeling of a random or facile Rube Goldberg machine by their clarity, almost purity, and their suggestion of something haunting or even menacing, as well as eccentric.

The present drawing, dated 1952, is one of Tanguy's most important from the last years of his life. Executed after he had been in the United States for more than a decade, it shows his tendency in these last works to emphasize a large panel—or canvas or screen—in the center of the sheet, with only a few blurred forms within it, contrasting with the highly detailed constructions beneath and around it. The large, flat, black forms which began to appear to the side in his drawings about 1949 (*19th and 20th Century French Drawings* . . . , Princeton, 1972, p. 86, and *Selected Sculpture and Works on Paper*, Solomon R. Guggenheim Museum, New York, 1969, p. 86) have here been integrated into the structural system of the whole work. The large blank panels also appear in his paintings from these last years, such as *The Transparent Ones*, 1951, Tate Gallery, London.

KURT SELIGMANN Basel 1900 – 1962 New York

87 AURORA, LONELYNESS AND SEED

Graphite and yellow, blue, rose, and orange colored pencils on cream wove paper. 27⅝ × 37⅛.
Inscribed in graphite, lower right, *Aurora, lonelyness and seed. K. Seligmann 1942*.
PROVENANCE: Durlacher Brothers, New York, ca. 1942–1943.
EXHIBITION: 55th exhibition of American watercolors and drawings, Art Institute of Chicago, 1944.

Anonymous lender.

Kurt Seligmann was born in Switzerland, spent the years 1927–1929 in Italy, and then went to Paris for the next ten years, where he became a member of the Surrealist circle; in 1939 he went to New York, where he remained until his death. Although he was a painter and a designer of ballet sets and costumes, his best work was, perhaps, in his prints and drawings (Robert Motherwell, no. 94, studied printmaking with him in 1941).

The present drawing, with its reminiscences of Tanguy and Ernst, is typical of his work, with its microscopic forms become monumental, mysteriously wrapped, like ominous buds or prisoners or bandaged wounds, towering over the landscape, like Tanguy's ramshackle constructions of bones among lunar dunes. Two other drawings, companion pieces, in the same collection, bought from the same exhibition and also dated 1942, are in pen and black ink and show more explicitly aggressive, warlike organisms, metal-plated, which are closer to Dali. The wrapped figure makes its appearance in Seligmann's work as early as 1938, where his mannequin for the "Surrealist Street" in the *Exposition Internationale du Surréalisme*, Paris, 1938, is a sheet over an armature, surmounted by a laurel wreath. Although these same forms appear in his paintings, such as the one, dated 1944, in the Smith College Museum, they are most frequently found in several of his prints from 1941 (*Kurt Seligmann, his Graphic Work*, La Boetie, New York, 1973, especially no. 90), his brilliant set of six etchings for *Oedipus* (nos. 102–107), and again in 1947 (no. 111).

ALBERTO GIACOMETTI *Stampa, Switzerland 1901 – 1966 Chur, Switzerland*

88 PORTRAIT OF BELLE KRASNE, I

Graphite on modern wove paper. Watermark: *B F K Rives*. The left edge is irregular (where the sheet was attached to a sketchbook). 19¹⁵⁄₁₆ × 13¼, lower edge; upper edge, 12¹¹⁄₁₆.
Inscribed by the artist in graphite, *A Belle Krasne trés* (sic) *amicalement | Alberto Giacometti 1953.*
PROVENANCE: Acquired from the artist, 1953.
LITERATURE: *Drawings and Watercolors from Alumnae and their Families*, Vassar College, 1961, no. 148.
Belle K. Ribicoff (Mrs. Irving S. Ribicoff).

Born in the Italian part of Switzerland, Giacometti emigrated to Paris in 1922, where he remained for most of the rest of his life. There, like Germaine Richier, he was a pupil of the sculptor of monumental, melodramatic figures, Emile Bourdelle. Giacometti's own sculpture evolved, in the early 1930's, into some of the most imaginative and clever embodiments of the Surrealist movement; it was only during World War II that he created his best known style, the long, emaciated, desolate figures, standing or walking, face forward, in profound spiritual isolation, their surfaces rough and mottled, like those of Bourdelle's sculpture.

His paintings, drawings, and lithographs, although less important to him than his sculpture, have many of the same characteristics: they are frontal, symmetrical, carefully restrained, elongated with large eyes, clearly defined in space and yet almost dematerialized. This last effect is achieved by making the figures semitransparent, so that rectangular grid lines become visible within the head and body themselves. The drawings are in pencil, and the paintings almost always in a virtually monochrome blue-grey, with an "unfinished" quality to the surface of the paint. Although he executed a few landscapes and still-lifes, which recall similar works by Morandi, he rarely interrupted his concentration on the vulnerable, isolated, single figure, here the portrait of the collector herself.

A Bella Krasne très amicalement
Alberto Giacometti 1953

SALVADOR DALI Figueras *1904 –*

89 RHINOCEROS

Graphite, black ink with brush, grey wash, and white gouache on white wove paper. 33¾ × 23⅜ (sight).
Signed in black ink with brush, *Dali 1959.* Inscribed, lower left, in graphite, DALI—SESKIRA (A PARAITRE *en octoBRE* | PRÉSENTEN | POUR PARETRE EN octoBRE | —all crossed out) | RINOCEROS | LE MAGASIN DE LA MAXIMUM POTETIALITE SPIRITUELLE- | POR LE Naif (—?—) LECTEUR, EXIJAN: | L'UNITE ALERTE (in blue pencil) (COSMIque—crossed out) LA (in blue pencil) COSMOGONiquE DE NOtre SIECLE | (LE CONCILE—crossed out) FUTUR CONCILE EUCONOMique DE PAPE JEAN 23 | LES NOUVELLES VALEURS MORALLE, (DE LA—crossed out) ET CIENTIFIQUES | RUSSIE (L'ES—crossed out) (LES POSIBLES—crossed out) L'ECUATION D'EISENBERG ET | LES POSIBILITES D'ESTRUITURE DE L'ANTI MATIERE | LA NOUVELLE "ENERGIE DU DEAI L'INMI (—?—) (LA—crossed out) PEINTURE—REALISTE CUANTIQUE" | EMERGAN DE L'ABSTRAIT—LE "CLEDALISME" NOUVELLE CONCEPTION | GOTIQUE de l'AMOUR— L'ORFEBRERIE ELECTRONIQUE—L'ARCHITECTURE (ANTIFONTIONELLE—crossed out) | (SUPER— crossed out) (SUPER—crossed out) (SUPRA GAUDINIENE—crossed out) A TRACTION DINAMIQUE—— | A PARETRE EN OCTOBRE 1959—DALI 1959. Inscribed at the lower center in graphite, RINOCEROS *LE* MAXI-MUM DE FORCE ESIRITUELLE | SESKIRA en (—?—) | LE MAGACIN DE LA MAXIME TENSION ESPI-RITUELLE | L'UNITE COSMIGONIQUE DU MONDE | (DE LA RE—crossed out) DU BON PASTEUR (—?—) EAN | L'UNITE in (|) l'inDETERMiniSME DEISENBERG.
PROVENANCE: Christie's, London.

Anonymous lender. John Constable

Dali's remarkable Surrealist paintings of the 1930's transformed his sources, which include De Chirico and the *scuola metafisica*, Miro, Ernst, and Tanguy, as well as Arcimboldo and art nouveau, to create a world that was completely clear and exact, and yet irrational and disturbing. Throughout his career, his drawings have been among his most controlled and powerful works, and the present, very large drawing, and particularly his *Good Shepherd* of the year before, 1958 (*Salvador Dali 1910–1965*, Gallery of Modern Art, New York, 1965, no. 218, and p. 131), have much in common with such virtuoso productions of the 1930's as his *Cavalier of Death*, Museum of Modern Art, New York, with its splashes of ink and restless line.

This portrait of a rhinoceros is, surprisingly, very careful and literal, as if the actual strangeness of the animal were eccentricity enough; Dali manages to give the feeling of a sensitive human sensibility behind a horribly deformed face. Although elephants, with their unusual noses, had appeared in his work since the 1930's, the rhinoceros seems to appear only about the mid-1950's; in 1954, he began his film, *Prodigious Adventure of the Lacemaker and the Rhinoceros*, one more example of his fascination with Vermeer, and in 1956 he draws a cover for an exhibition catalogue at Knokke, titled *Nitzcheens vers le haut!*, with numerous rhinoceros tusks flying through the air and a large tusk growing out of the bald head of a woman out of whose breast a drawer has been pulled. Finally, in 1970, he executes a gilded bronze death mask of Napoleon, whose bottom half is a rhinoceros, dedicated to President Pompidou (*Dali*, Museum Boymans-van Beuningen, Rotterdam, 1970, no. 197). The present drawing has references, at the bottom, to Pope John XXIII and Gaudi, whose architecture he loves and has called "undulant—convulsive." This author could find no record of a magazine titled *Rhinoceros*, to which the inscription refers (aside from a scholarly journal in German); in 1959, Ionesco's play *Rhinoceros* was first published.

WILLEM DE KOONING Rotterdam 1904 –

90 STANDING WOMAN

Graphite and black, pink, yellow, red, blue, and brown colored chalks on cream wove paper. The paper's verso is printed in a black grid of four centimeter squares. A strip of the same paper, but with the grid not aligned, has been added along the bottom edge of the main sheet with masking tape. The drawing's framing lines are drawn over both pieces of paper. Design sheet: 21⅜ × 16; full sheet with added strip, 24¼ × 16.

Signed in graphite, *de Kooning*. Inscribed in graphite on the lower strip, probably in the artist's hand, *NO 16* (underlined) | *mat 2½″ all around | ivory | small frame*. Inscribed in ball-point pen in another hand on the same strip, *op – 14¼ × 21½*.

PROVENANCE: Allan Stone Gallery, New York; Sidney Janis Gallery, New York; Barry Benepe.

LITERATURE: *20th Century Master Drawings*, Fogg Art Museum, 1963, no. 65; Thomas B. Hess, *Willem de Kooning*, New York, 1968, p. 86; Thomas B. Hess, *Willem de Kooning · Drawings*, Greenwich, Conn., 1972, p. 148, no. 56.

Mr. and Mrs. Stephen D. Paine.

Although single figures of women had been a continuous concern of the artist since the late 1930's, it was about 1947 that De Kooning began to infuse these figures with an almost demonic intensity, even while his paintings and drawings were still, for the most part, composed of completely non-figurative, flat shapes (e.g., the major drawing from about 1950, Museum of Fine Arts, Boston). The breakthrough came in 1950 with his *Woman* series, particularly *Woman I*, in the Museum of Modern Art, New York, and this preoccupation continued until 1953. In that year, and certainly by 1954, his *Woman* drawings are fewer and the figures begin to spread out across the page, abstracter (e.g., his 1954 drawing, Whitney Museum, New York), and he has become totally nonfigurative again by the late 1950's. Interestingly enough, in the middle and late 1960's, he returned again to the theme of the woman in both paintings

and drawings, now more explicitly erotic, often with spread legs.

In the present, relatively highly finished drawing, which is near the end of the *Woman* period, ca. 1952, the flat planes that characterized his figure studies of the late 1930's and early 1940's, basically derived from the Cubist Picasso, are still being used for the breasts, the right arm, the legs from the knees down, and that part of the chair visible in the upper right. In fact, the whole figure seems shoved and cramped into a single unit that is pushed forward toward us, almost into a single plane. This separate body "unit" is isolated in space on the paper, a space enlarged by the addition of another sheet (of European metric paper) at the bottom. Instead of losing volume and intensity, as with his quiet, melancholy, Balthus-like women of the early 1940's, this planarity, like sharp, flat aluminum sheets, gives these figures weight and a savage energy.

ARSHILE GORKY *Khorkom Vari, Haiyotz Dzor, Turkish Armenia 1905 –*
1948 Sherman, Connecticut

91 COMPOSITION. Verso: unfinished sketch.

Black ink with steel pen and wash; blue, aqua, green, yellow, violet, and orange crayon on yellowish wove paper with a roughly pebbled texture. The verso drawing is in black ink with a steel pen. 20 × 26¼.
PROVENANCE: Malcolm Cowley, from the artist's widow.
LITERATURE: *Boston Collects Modern Art*, Rose Art Museum, 1964, no. 40.

Mr. and Mrs. Stephen D. Paine.

Arshile Gorky, who was born in Turkish Armenia but emigrated to the United States at fifteen, was one of the major figures of the Abstract Expressionist movement; this drawing shows clear connections, stylistically and emotionally, with other drawings in this exhibition by De Kooning, Pollock, Smith, and Motherwell. His work in the early 1930's was largely derived from Picasso and Synthetic Cubism, concerns still evident in his mural for the Newark Airport in the mid-1930's. By the end of that decade and the beginning of the 1940's, his work had shifted to an increasing awareness of the attenuated, vaguely animal or vegetable forms floating in an undefined space that characterized the work of Miro and Matta, and of such Surrealists as Ernst and Seligmann. Gorky transformed these shapes by having areas of paint drip and slide down the canvas and by using more garish colors and more blacks, into a vision of a world more fragmented, frightening, agonized.

The present drawing is probably from 1945 or 1946, and resembles such paintings as *The Unattainable* and *Landscape Table*, both of 1945, and *Charred Beloved*, 1946. In the latter year, he lost a large number of paintings and drawings in a fire and underwent an operation for cancer; two years later, he broke his neck and paralyzed his painting arm, and committed suicide.

DAVID SMITH Decatur, Indiana 1906 – 1965 Bennington, Vermont

92 THREE VERTICAL FORMS

India ink, egg yolk, and watercolor, on modern laid paper. Three watermarks on the handmade paper, Charter Oak, England: upper left, the sudarium of St. Veronica, and beneath it, *1399*; lower left, *F J H* (in script); upper right, an open left hand, with a cuff over the wrist, and a small quadrifoil, or cross, on the tip of the middle finger. 1½ inch vertical tear, bottom edge. 20³⁄₁₆ × 15³⁄₈.
Inscribed in pen and black ink, over lines in black chalk on graphite, *D S 15/5/4/53*.

Belle K. Ribicoff (Mrs. Irving S. Ribicoff).

The work of David Smith, perhaps America's greatest sculptor, grew out of a style in the 1930's indebted to the Surrealism of Giacometti, the wrought iron figures of Gonzalez, and the constructions of Picasso to larger steel figures in the 1950's, wiry and dynamic, but still with some echoes of surrealist imagery in their suggestions of animal and vegetable growths, to, finally, his crowning achievement, in the 1960's, the *Cubi* series, simple, monumental, stainless steel sculptures that open up across the landscape.

Although often superb works of art in their own right, his drawings clearly follow his development as a sculptor. The present work, dated 1953, has all the characteristics of his sculpture in the early 1950's: long, thin, with broad forms alternating with thin and curves with straight lines, and the hint of some kind of being, however abstract, still living within the forms. This relationship may be seen with his *Tanktotem* series of 1953, the *Sentinel* series of 1957, and, most particularly, with *Birdheads*, 1950, Lee Baker collection, Baltimore (Rosalind E. Krauss, *Terminal Iron Works, The Sculpture of David Smith*, Cambridge, 1971, fig. 56). Marjorie B. Cohn (letter, March 27, 1973) has pointed out that Smith used the finest and most expensive papers for his important drawings.

93 WATERCOLOR NO. 8

Dripped and blotted black ink, colored inks, and drops of white oil paint, on rice paper; laid down. 24⅛ × 39 (slightly irregular).
Signed in pen and black ink, *Jackson Pollock 51*.
PROVENANCE: Betty Parsons Gallery, New York.

Mrs. Jean Brown.

This masterpiece of 1951 was executed at a crucial moment in Pollock's career. In 1950, Pollock had achieved a large measure of success, not only in New York, but at the Venice Biennale, and Hans Namuth had made his famous film of him, painting on glass. Although 1952 was to see perhaps his greatest painting, *Blue Poles*, this was also the year when his stylistic development seemed to end and his problems with alcoholism became more severe. Thus, in 1951, when he had a car accident, his work was already in a state of transition; black and white, in paintings as well as drawings, became a more important means of expression for him, and figurative elements began to recur, recalling his work of a decade earlier (as in his painting, *Number 3, 1951*, Robert U. Ossorio, New York).

His drawings of 1951 are less dense and highly worked than those of 1949 and 1950, or such a remarkable painting as *Number 32, 1950*, Kunstsammlung Nordrhein-Westfalen, Düsseldorf. The present work, however, is one of the finest of that year and is more integrated, less fragmented and disjointed, than most of his drawings of 1951; it shows clearly how close the process of drawing was for him to the process of painting (and also why, in his earlier sketchbooks, he had made copies after the works of Rubens). Although this work is close to, for example, his drawing, *Number 3, 1951* (Mr. and Mrs. Alexander Liberman, New York), which has precisely the same dimensions, it still seems less clotted, freer and more spontaneous in its movement.

ROBERT MOTHERWELL *Aberdeen, Washington 1915 –*

94 BESIDE THE SEA, NO. 31

Acrylic on paper. 28¾ × 22⅜.
Signed in graphite, upper right, *R M 62*; inscribed in graphite, lower right, *31*.
PROVENANCE: Acquired from the artist.

Professor and Mrs. S. Lane Faison, Jr.

Robert Motherwell has been not only a painter, draughtsman, and printmaker, but also an editor, art historian, and poet, responsive to the various streams of culture and politics in the twentieth century, a preoccupation that is clear in the titles of his paintings, such as *Dublin 1916*, and the series which began in 1948 and lasted into the 1960's, *Elegy for the Spanish Republic*. Motherwell's intimate involvement with the major outburst of American painting, based in New York, in the 1940's and 1950's may be seen by comparing this drawing with those in this exhibition by Arshile Gorky, Jackson Pollock, and his close friend, David Smith.

This series of drawings, *Beside the Sea*, of which there are at least thirty-one (six are reproduced in Frank O'Hara, *Robert Motherwell*, New York, 1965, pp. 32–33, and a seventh, extremely close to the present drawing, in *Robert Motherwell*, St. Gallen, 1970, p. 12), heralds a change in the artist's work in the early sixties away from the massive vertical forms of the *Elegy* series. This basic format of a strong base with dynamic, curving form above, spattered on, soon appeared in the paintings, such as his series, *Indian Summer*, 1962–1964. The use of drawings as a way of entering a new phase of his stylistic development in larger media—a typical function of drawings—is seen in his *Lyric Suite*, a group of hundreds of ink sketches done on Japanese rice paper, done in six weeks in 1965. Here, the placing of forms in the center of the paper, perhaps influenced by the work of his wife, Helen Frankenthaler, evolved in the late 1960's into a greater simplicity, large paintings with open fields of a single color broken into only by a few harsh lines, almost scratches, forming a rectangle and the suggestion of another shape within the painting. Motherwell's latest drawings, his *Gesture* series of 1971, in many ways recall the earlier works, *Beside the Sea*, whose title reinforces the suggestion of waves and flat shore.

CLAES THURE OLDENBURG *Stockholm 1929 –*

95 1936 BLUE CHRYSLER AIRFLOW

Red, blue, grey, and black acrylic spray paints and metallic silver-colored paint applied with a brush, graphite, black ball-point ink, stencil effects, and many tack holes on a collage of various white wove papers, including printed (blue grid) graph paper. There is a slight stain from double-sided masking tape used along the bottom edge of the collage. 29½ × 22⅛.

The design area is inscribed in black ball-point ink to identify various elements and positions of the design (e.g., *top /side / cloud #9*). Signed in graphite, lower right, *Claes Th. Oldenburg.* Inscribed by the artist in black ink (felt tip) at the lower edge, (vertical arrow) *UP* NOTE: FiIGURE (IS—crossed out) SHOULD BE / UPSIDE DOWN. Inscribed by the artist in black ink (felt-tip and ball-point) five times, (vertical arrow) *UP.*

PROVENANCE: Sidney Janis Gallery, New York.

LITERATURE: Gene Baro, *Claes Oldenburg. Drawings and Prints*, London and New York, 1969, no. 263.

Wasserman Family Collection.

This drawing is the preparatory study for the cover of *Art News*, February, 1966. The cover was meant to be cut out and folded together to form a box, with the image of the Chrysler on all sides, a multiple in an edition of 36,000. Oldenburg's insistence, on the drawing, that the figure, drawn from a photograph of the car's inventor, Carl Breer, be printed upside down emphasizes that the human is no more or less real than the car itself. As with Arakawa and Johns, the words are written over the images of the things they describe, such as "top" or "side" or "cloud." Oldenburg's fascination, in the mid-1960's, with the Chry-slers built between 1934 and 1937 was part of his nostalgia for the '30's, clear again, more dramatically, in Ed Kienholz's *Back Seat Dodge 1938.* The artist has done other cut-out drawings, including a self-portrait, with an icebag-beret on his head and diagrammed tears on his face (Barbara Haskell, *Claes Oldenburg. Object Into Monument*, Pasadena, 1971, pp. 130–131). The humorous and slightly disturbing edge to this drawing is typical of his large body of works, ranging from soft versions of everyday objects to bedroom ensembles to painted plaster food to proposals for public monuments in various cities.

UP

TOP

UP

↑UP NOTE: FIGURE IS SHOULDE
 UPSIDE DOWN

JASPER JOHNS *Augusta, Georgia 1930 –*

96 NUMBERS

Graphite, grey wash, and gouache (?) on white wove paper laid down on a second large sheet. The design's edges extend onto the mounting sheet. Some viscous substance has been applied as one of the lower layers of pigment on this composition of many layers. It gives an effect of impasto, but as it is covered over with graphite and wash, the material cannot be positively identified. Design sheet: 20⅝ × 18; mounting sheet: 23 × 26½.
Signed in graphite on the mounting sheet, lower right, *J. Johns '60.*

Mr. and Mrs. Stephen D. Paine.

The theme of numerals, 0 through 9, has been one of Jasper Johns's favorite subjects; in 1957 he executed a large painting of precisely this composition (Robert C. Scull collection, New York), and in 1967 he made a precisely similar lithograph (Field, no. 61). The numbers form a self-contained system— arranged in eleven rows and eleven columns, with the upper left corner blank but a 9 in each of the other corners, with the second row beginning with 0 and ending with 0, the third beginning and ending with 1, and so on, with various other such patterns present in it. In other words, the numbers form a system of their own, don't go anywhere or prove anything. This aloofness is part of the essence of Johns's work, what Leo Steinberg has called "the intensity of their solitude" (Leo Steinberg, *Jasper Johns*, New York, 1963, p. 32). The choice of numbers as images is related to his choice of flags and targets and words, marks on a surface that still do not have illusionistic depth. Although superficially related to Pop Art, Johns, instead of emphasizing the vulgarity, destructiveness, or humor of everyday objects, finds a beauty and integrity within them. This drawing is amazingly painterly, and the different levels of impasto and drip give a sense of recession that is immediately brought into balance, flattened out, by the subject and the uniform grey.

CHRISTO (JAVACHEFF) Gabrovo, Bulgaria 1935 –

97 STUDY FOR THE VALLEY CURTAIN PROJECT, 1971

Graphite; black, brown, orange, yellow, and green crayon; white gouache; photographic images; and salmon-colored muslin stapled and taped on white wove paper. 28 × 22.
Inscribed in graphite through the lower center at the bottom of the main design area: VALLEY CURTAIN (PROJECT FOR COLORADO) RIFLE, 261 MILES WEST FROM DENVER, 7 MILES NORTH FROM RIFLE; WIDTH: 1350′; HEIGHT: 205′ – 305′: *Christo 1971.* Inscribed on the original of the image here represented by a photographic image: PROFILE OF RIFLE GAP ALONG A LINE INDICATED IN THE LETTER / OF FEBRUARY 11, 1971 FROM CHRISTO TO TRI-CO MANAGEMENT, INC. / ON A MAP OF RIFLE GAP BY AIR PHOTO SURVEYS: GLOBAL / ENGINEERING, INC. Various notations of direction, dimension, and identification of design and landscape elements (e.g., EAST, 1250′ 0″, CABLE CLAMP CONNECTION).

Mr. and Mrs. Stephen D. Paine.

Christo is one of the most important artists connected with the concept of earth works and art as inseparable from the natural and man-made environment. His concern has been to wrap objects, from motorcycles to store fronts to whole buildings to a long portion of the Australian coast to empty air. In each case, the addition of opaque or semi-transparent wrapping has given the object a pregnancy, a potential for change and transformation, an extra possibility—the thing wrapped remains itself but is also something else.

This drawing is one of a large number that the artist made to finance the erection of an orange curtain, to be stretched across a valley near the town of Rifle Gap, Colorado. There are, here, three different images of the canyon and the project: a photo of a graph made by a surveying firm, a photo of the canyon, retouched in ink, and a drawing of the canyon with red cloth stapled to it. After many travails (Jan Van der Marck, "The Valley Curtain," *Art in America*, May–June, 1972, pp. 54–67), the curtain fell down just before it was due to be unfurled, in October, 1971; the next year, it was erected once again, lasting less than a day this time. Earlier, in 1962, Christo had erected another kind of obstruction, his *Iron Curtain* of oil drums, across the rue Visconti, in Paris.

208

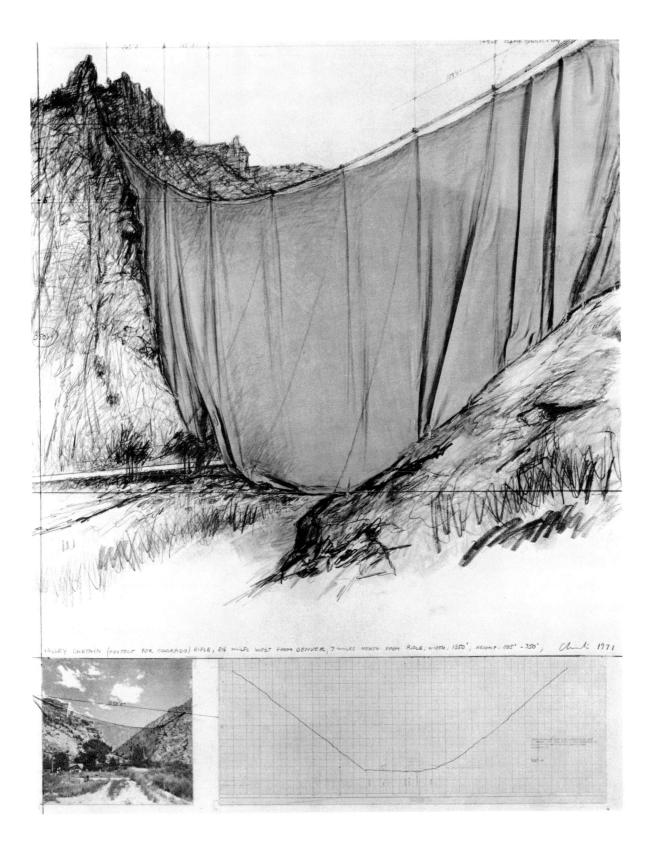

VALLEY CURTAIN (PROJECT FOR COLORADO) RIFLE, 216 MILES WEST FROM DENVER, 7 MILES NORTH FROM RIFLE; WIDTH: 1350', HEIGHT: 205' - 350', Christo 1971

SHUSAKA ARAKAWA *Tokyo 1936 –*

98 I WAS LOOKING AT A YELLOW TABLE

Graphite and yellow tempera on white modern laid paper. 35⅛ × 43⅞.
Signed in graphite, lower right, *arakawa / 1970*. Inscribed in yellow tempera and brush through the center, *I was looking at a yellow table 11. 3. 70*; inscribed in graphite, lower center, *I was looking at a yellow table 11. 3. 70*.
Mr. and Mrs. Roger Sonnabend.

Arakawa, who has lived and worked in New York since 1961, is, like many concept artists, concerned with the act of seeing and the question of what a work of art is—an object itself, the illusion of another object, or the verbal equivalent of the object. Here we are given nothing but a table, drawn in a simple, text-book perspective (left unfinished at the left), and we see that this perspective—the essence of illusionism—can create an image that is anything but illusionistic, an effect reinforced by the flat bands of yellow tempera that do not recede or respond to light and shadow. The idea that we intellectualize our perceptions, that is, that words and concepts are part of our seeing, is emphasized by the words the artist has written, in yellow again, within the table, denying its illusion and drawing our attention again to the paper itself, whose surface has a tactile, slightly pebbled texture. The signing and dating in the lower right, when it has already been dated elsewhere on the sheet, tend to set the whole "image" off as a work of art; both the table and the act of seeing the table constitute the whole work, which he then signs. In this context, the fact that this is a drawing, a notation, rather than a painting, becomes part of the theoretical content of the work. What is remarkable is that, with all this concern with conceptualization, the resultant image, with its severe, straight lines and bright yellow on pure white paper, is attractive and lively.

WILLIAM T. WILEY *Bedford, Indiana 1937 –*

99 THE DOVE TOWN FERRY RUNS BOTH WAYS

Black ink with felt-tip pen and multi-colored watercolor on white wove paper. Design area: 17 × 25¾; sheet size: 22 × 30.

Signed in black ink along the bottom edge below the design area: *9/1/69 The Dove Town Ferry Runs Both Ways Wm. T. Wiley*; inscribed in ink and watercolor as graffiti in the design area: JESUS / SLAVES (black ink and yellow watercolor with the L in orange); GURU / GETS ALL / HE WANTS (blue ink); SAVE YOUR / SELF (green and brown ink); NATIVE / STONE (brown ink); AHAB EAT / IT (blue ink).

Mr. and Mrs. Stephen D. Paine.

William Wiley is one of the most important exponents of Funk art. Derived from a word used to describe the unsophisticated blues played by marching bands in New Orleans (Peter Selz, *Funk*, Berkeley, 1967, p. 3), Funk differs in several respects from Pop Art, which also focusses on everyday, disposable objects. It is more blatantly erotic, more concerned with verbal and visual puns, in worse taste, more repellent, than Pop Art painting and sculpture; based in California and especially San Francisco where there was an exhibition, *Common Art Accumulations*, as early as 1951, it is closer to Surrealism and Dada and less responsive to the notions of picture plane and picture space which connect the Pop artists with modernist painting of Noland and Stella. Funk artists are more indebted to the generation of Beat poets.

Wiley's drawings are important not so much for the cleverness of his puns, like *Jesus Saves/Slaves* or *Wizdumb Bridge*, but for their obviousness, combined with what seems at first sight to be a conventional visual language, which is skewed just enough to make it unsettlingly real. His draughtsmanship has a *horror vacui*, the quality of a mosaic or crazy quilt, built up out of straight lines and rectangles, with strong local colors and little shadow—an apocalyptic children's book illustration.

Wiley, who teaches at the University of California at Davis, has written (letter, March 7, 1973) that this drawing is "about a time in my studio when I was thinking about the War and Religion—and the work I guess is an attempt to hover those issues without them landing too quickly on anyone's side of the fence." Wiley has also made films and sculpture; his drawings have influenced the work of a number of artists, particularly that of Gunars Strazdins, Bob Camblin, and Susan Hall.

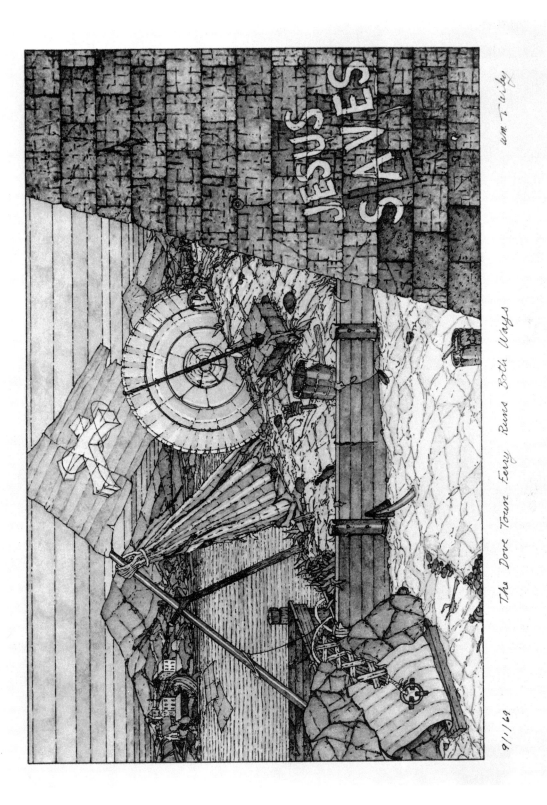

9/1/69 The Dove Town Ferry Runs Both Ways Wm. Tailby

CHUCK CLOSE *Monroe, Washington 1940 –*

100 SELF-PORTRAIT

Graphite with extensive stumping, erasure, and scratchwork on white wove paper. Papermaker's blind stamp: STRATH-MORE in a circle. 29⅛ × 23.
Signed in graphite, lower right, *Close 1968.*

Mr. and Mrs. Stephen D. Paine.

This brilliant drawing is a preparatory study for the artist's *Self-Portrait*, 1968, in the Walker Art Center, Minneapolis. Close studied at the University of Washington, Yale, and the Akademie der Bildenden Künste, Vienna, and is, at least superficially, related to a variety of contemporary artists whose work seems to respond to "photographic reality." Although the subjects of some of these artists include such artifacts of American life as car engines and movie theater facades, Close's work is most clearly connected with that of Philip Pearlstein, who also tries to make the viewer look at the human body in non-traditional, non-sentimental ways, as if he were against eloquence.

This drawing is all the more remarkable considering Close's working methods. In working toward the finished painting—his *Self-Portrait* is 9 × 7 feet—he uses a series of photographs of the face in question, building up from a section, the eyes, in very sharp focus to other areas out of focus, in this case, the tip of the nose and the cigarette. Such a painstaking approach—he also has transferred his painting *Keith* into a very large mezzotint, an unusual medium in 1973—creates a work of art that is not so much illusionistic as informational. Close remarked in an interview (Cindy Nemser, "An Interview with Chuck Close," *Artforum,* January, 1970, p. 51) that his "main objective is to translate photographic information into paint infor-

mation. . . . The camera is objective. When it records a face it can't make any hierarchical decisions about a nose being more important than a cheek." Because his approach, superficially traditional, is basically radical—"I think it is useless to try and revive figurative art by pumping it full of outworn humanist notions" (p. 55)—the artists he most respects are those whose work is nonfigurative, such as Serra, Stella, Noland, and Morris. "I too want to strip the viewer of the comfort of thinking that the traditional concepts of art he has been dragging around are automatically going to make him understand what art today is all about" (p. 55).

The present drawing differs subtly from the finished painting: aside from such details as the fact that the drawing is in reverse from the painting (the part in his hair is on his right and the cigarette is on the other side of his mouth, details which suggest the use of a mirror), the image in the drawing is less harsh and less stark, the shadows, particularly around the eyes, are less dark, the hair tumbles across the forehead instead of being pulled straight to the side, the image is cut off above the collarbone so that we don't see these sharp lines. Altogether, the figure in the drawing looks younger, less sure of himself, more approachable; most of Close's later drawings are series of dots on impersonal, objective graph paper, for transfer to paintings.

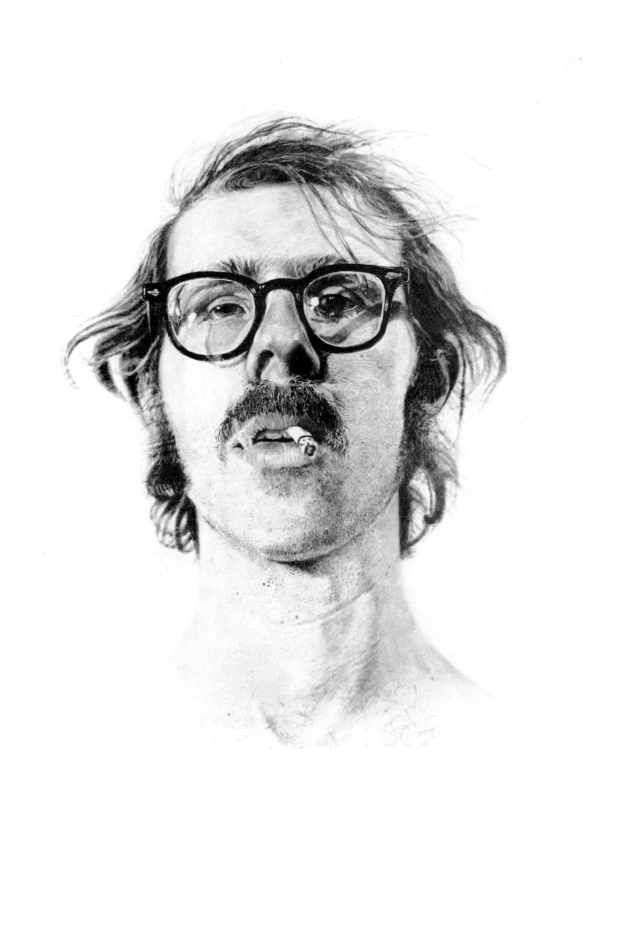

Versos

9. *verso*, Bloemaert

26. *verso*, Cuyp

55. *verso*, Pissarro

62. *verso*, Cézanne (detail)

78. *verso*, Kirchner

85. *verso*, Shahn

91. *verso*, Gorky

Index of Artists

by catalogue entry number

PHOTOGRAPHIC CREDITS E. Irving Blomstrann: 55, 63, 64, 71, 73, 83, 86, 88, 92; Barney Burstein: 51; Cleveland Museum of Art: 12; Dartmouth College Photographic Service: 54; Hyman Edelstein: 7; Fogg Art Museum: 57; Howard Levitz, Sterling and Francine Clark Art Institute: 2, 5, 17, 41, 42, 46, 65, 70, 82, 84, 93; Museum of Fine Arts, Boston: 43; Walter H. Scott: 47, 48, 61; Joseph Szaszfai: 53; Herbert P. Vose: 1, 3, 4, 6, 8–11, 13–16, 18–40, 44, 45, 49, 50, 52, 56, 58–60, 62, 66–69, 72, 74–81, 85, 87, 89–91, 95–100; Williams College: 94.

Printed by The Stinehour Press
and The Meriden Gravure Company